IMAGES
of America

CHEYENNE
RIVER SIOUX

SOUTH DAKOTA

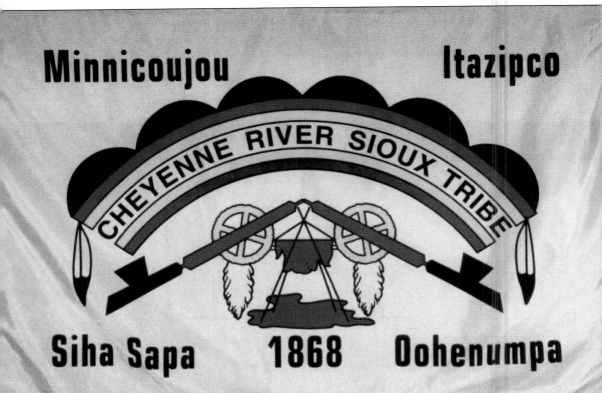

CHEYENNE RIVER SIOUX TRIBAL FLAG. The flag was designed by tribal member Sidney Keith. The blue represents the Thunder Clouds where the thunderbirds who control the four winds live. The rainbow is for the Cheyenne River Sioux people who are keepers of the most sacred Calf Pipe, a gift from the White Buffalo Calf Maiden. The eagle feathers at the edge of the rim of the world represent the spotted eagle who is the protector of all Lakota. The two pipes fused together are for unity. One pipe is for the Lakota, the other is for all the other Indian nations. The yellow hoops represent the sacred Hoop, which shall not be broken. The Sacred Calf Bundle in red represents Wakan Tanta—The Great Mystery. All the colors of the Lakota are visible. The red, yellow, black, and white represent the four major races. The blue is for heaven. (Photograph courtesy of Donovin Sprague.)

IMAGES
of America
CHEYENNE
RIVER SIOUX
SOUTH DAKOTA

Donovin Arleigh Sprague

ARCADIA

Published by Arcadia Publishing,
an imprint of Tempus Publishing, Inc.
3047 N. Lincoln Ave., Suite 410
Chicago, IL 60657

Printed in Great Britain.

Library of Congress Catalog Card Number: 2002117421

For all general information contact Arcadia Publishing at:
Telephone 843-853-2070
Fax 843-853-0044
E-Mail sales@arcadiapublishing.com

For customer service and orders:
Toll-Free 1-888-313-2665

Visit us on the internet at http://www.arcadiapublishing.com

With love to my parents, Darrel and Velda Sprague who understood the meaning of life and family, and to the memory of my sister Lila.

CONTENTS

Acknowledgments 6

Introduction 7

1. Wico Ahi Tokahe (Early Visitors) 1832–1833 and 9
 Wicite Owapi Tokahe (The First Photos) 1850–1870

2. Maka Blu Wakpa Makoce (Powder River County) 17
 Fetterman Okicize (Fetterman Fight)
 Canpagmiyanpi Okicize (Wagon Box Fight)
 Maga Wakpa Okicize (Hayfield Fight)
 Sicangu Okicize (Battle Of The Rosebud)
 Peji Sla Okicize (Greasy Grass-Battle of The Little Big Horn)

3. Pte Hincala Wakan Canumpa (Sacred Buffalo Calf Pipe) 47

4. Wanagi Wacipi (Ghost Dance) and 51
 Cank'pe Opi (Wounded Knee)

5. Wakpa Waste Owakpamni (Good River/Cheyenne Agency) 61

6. Owayawa El' Tipi (Boarding Schools) 113
 Wounspe Teca (New Education)

7. Okolakiciye Akicita (Soldier Society/Veterans) 115

8. Wakpa Waste Owakpamni Tanni 119
 (Old Chyenenne Agency/Good River)

9. Wicoicage Tokahe (The Next Generation) 127
 Wacipi (Powwows)
 Sunkwatogla Akanyanka (Rodeo)
 Psa Wognake Tap Skata (Basketball)
 Skal O Mani Pi (Sporting Events)

ACKNOWLEDGMENTS

My special thanks and appreciation go to those who have assisted me in this project. Thank you for photos, history, generosity, and conversation to all, past and present: Bryan Akipa, Kay Knife Allison, Bill Anderson Family, Charlene Anderson–Enrollment–Cheyenne River Sioux Tribe, Paul Anderson Family, Lou Ann Barton, Frank and Gwen Baum, Irene Bedard, Mildred Benway, Black Hills State University–E.Y. Berry Library Learning Center, Lorenzo Black Lance, Gregg and Kay Bourland, Doyle Bramhall, Jodee Brewer, Eugenia Burgee, Cheyenne River Sioux Tribe, CRST Nutrition Center, Chips Family, Jay Citron, Eddy Clearwater, Delmar Clown, Floyd Clown, Clown Family, Pat Condon and Family, Crazy Horse Memorial, Dakota Drum, Kitty Deernose–Curator–Little Bighorn National Monument, Denver Public Library, Dewey County History Book Staff, Fred Dupree descendants, *Eagle Butte News*, Fabulous Thunderbirds, Wilbur Flying By, Billy Gibbons, Samantha Gleisten, Dorothy and Mario Gonzalez, Renee Greenman, John Gritts, Clarissa Gusman, Merle Haggard, Diane Hall, Ray and Marvel Handboy, Ted Harvey, Michael and Nicole He Crow, Edith Hein, Pete Helper and Darlene, Sharon Hemmingson, James Holy Eagle, Sonja Holy Eagle, Hump Family, Ellen In The Woods and Family, Iowa State University, Lonnie Jeffries, Waylon Jennings and Jessi, Irene Jordan, Sidney and Shirley Keith, Gay Kingman, Gus Kingman, KILI-FM Pine ridge Indian Reservation, KLND-FM Standing Rock/Cheyenne River, Jimmy D. Lane, Johnny Lang, Janna Lapidus, Ernie and Sonja LaPointe, Dave Laudenschlager and Family, Lewis LeBeau, Marcella Ryan LeBeau, Mary LeBeau, Bob Lee, Sis Lewis and Family, David and Joanie Lindley, David Little Elk, Leonard Little Finger, Barbara Logan, Lone Horn descendants, Clement Long, Bud Longbrake, Faye Longbrake, Jake Longbrake, Longbrake Rodeos, Carideo and Estherlene Low Dog, Ruby Marshall, Lawrence and Marion Mayes Estate, Terry Mayes, Pauline Meister, Janeen Melmer–Librarian–Crazy Horse Memorial, Freda Mesteth, Carol Michael, Berneita Miller and Family, Bonnie Miller, Montana State Historical Society, Michael Martin Murphy, Nebraska State Historical Society, Willie Nelson, Darrel No Heart, North Dakota Historical Society, Oglala Lakota College, Grant Olsen, Bob and Nell Pearson, Pooley Family, Scott Pourier, Marcie, Todd and Dylan Pudwill, Dollie Red Elk, Donnie Red Thunder, Susan Ricci, Irwin Richardson, Rock N Records, Jimmy Rogers, Lavera Rose, Junior Rousseau, Neil Rousseau, Belva Schad, Monica Garreau Schmidt, Dee Schumacher, Grover Scott, Dennis, Darrel, and Doren Serfling, Seven Council Fires, Shakedown, Tommy Shannon, Mark Shillingstad, Harold Shunk, Catherine Brings The Horses Silva, Nancy Sinatra, Elsie Slides Off, Smithsonian Institute, Brandon Sprague, Deb Sprague, Rylan Sprague, Hersil Sprague Family, Linda Stampoulos for making it happen, Evan Stampoulos, Ken Stewart at South Dakota State Archives, Edith Traversie, Ben Trent, Mike Trent Family, Mimi Tschida, Matt and Nellie Two Bulls, University of California, University of Iowa, University of Northern Iowa, University of South Dakota, Vance Family, Stevie Ray Vaughan, Odette (Claymore) Voss, Ron and Sue Wagner, Wakan Tanka, Doug War Eagle, Pauline Webb, Jim White Feather (who liked my fastball), White Wolf Family, Wico Hunkake, Inc., Kim Wilson, Wounded Knee Survivor Assn., Gerald Yellow Hawk, Jim and Ruth Yellow Hawk, Ed Young Man Afraid Of His Horses, Scott Zanger, Ziebach County History Book Staff, Ziolkowski Family, ZZ Top, and to all my high school and college friends.

INTRODUCTION

WAKPA WASTE (GOOD RIVER) HISTORY

The name Sioux is part of the Ojibway/Chippewa/Anishinabe word "Nadoweisiw-eg," which the French shortened to Sioux. The original word meant "little or lesser snakes/enemies." The Sioux are really three groups comprised of the Lakota, Dakota, and Nakota, each having slightly different language dialects. Geographically, the Lakota are the most western of the groups and there are seven distinct bands. Four of the Lakota bands (the Minnicoujou, Itazipco, Siha Sapa, and the Oohenumpa) are located on the land known as the Cheyenne River Indian Reservation and it is here that the book is centered. The other three (the Oglala of Pine Ridge Indian Reservation, Hunkpapa at Standing Rock Reservation, and Sicangu at the Rosebud Indian Reservation and also at Lower Brule Indian Reservation, are all located in western South Dakota. The Standing Rock Reservation also stretches into North Dakota. Some of the Lakota also settled in Canada at Wood Mountain Reserve in Saskatchewan beginning in 1876.

The present land base of the Cheyenne River Indian Reservation was established by the 1868 Fort Laramie Treaty. Prior to this, the bands placed within this reservation knew no boundary to their territory. They were a hunting people and traveled frequently in search of their main food source, the American bison or buffalo.

The Sioux Agreement Act of 1889 set reservation boundary lines and was named the Cheyenne River Sioux Reservation. The Cheyenne River flows towards the west from the Missouri River and was known to the Lakota as the Good River (Wakpa Waste). Fort Bennett was established on the Missouri River in 1870 and was near the Cheyenne Agency. Fort Bennett was the quarters for the Indian Agent and soldiers. Separate from the fort was an agency town that housed government employees. In 1872, the fort and Agency town were moved to higher ground away from the river. The fort and town would be moved a total of four times in the coming years, with the name Cheyenne Agency attached to the town adjoining Fort Bennett. As reservation land was ceded following the Dawes Act of 1887, the town was moved again since it was now off the new reservation boundaries. After 1891, Fort Bennett was closed by the military and the reservation was believed to be safe without a military fort beside it. The next location of the agency would be between the Cheyenne (Good River) and the Moreau (Owl) River at the site of Chief Martin Charger's camp. It was called Cheyenne Agency.

The final location of the Agency would be the town of Eagle Butte in 1959, a move necessitated due to the building of the Oahe Dam near Pierre, South Dakota, which flooded tribal lands along the Missouri. When people refer to the Old Agency or Old Cheyenne Agency, they are referring to the Agency location prior to the move to Eagle Butte. There is also confusion about the name Cheyenne as people often think the four bands located here are of the Cheyenne Tribe. Although the Lakotas have been close allies with the Cheyenne, they are, nevertheless, a different tribe. The Northern Cheyenne are located in Montana and the Southern Cheyenne are in Oklahoma.

The first towns were Evarts and then LeBeau which were trading posts. LeBeau was established by Antoine LeBeau, a French trader. Evarts and LeBeau became non-existent when railroad service left. The old main home camps of the Minnicoujou were in the towns of Cherry Creek, Bridger, and Red Scaffold in the western area of the reservation. The home camps of the

Oohenumpa went from Iron Lightning, Thunder Butte, Bear Creek, and White Horse, along the Moreau (Owl) River. The Siha Sapa located their people around the Promise and Black Foot areas in the northeast part of the reservation. Green Grass and the On The Tree communities were home to the Itazipco. Green Grass is home to the Sacred Buffalo Calf Pipe. Today, other communities on or near the reservation house tribal members including Eagle Butte, Dupree, Red Elm, Takini, Bridger, Howes, Glad Valley, Isabel, Firesteel, Timber Lake, Trail City, Swiftbird, LaPlant, Ridgeview, Parade, and Lantry. There are also many rural areas on the reservation.

There has been intermarriage between all Lakota bands and they should be considered as one (all related). This book will list people by their proper band names if known. There are different spellings of the bands but the author uses the spellings as adopted by the tribe as they appear on the tribal flag. An older name for Minnicoujou was Howoju meaning "the people." Minnicoujou means "planters by the water," Itazipco means "Without Bows," and the French called them Sans Arc. Siha Sapa means "Black Foot," and Oohenumpa means "Two boilings/Two Kettle." Many tribal members will find they are a mixture of the four bands. The current tribal enrollment is 10,724 members and the 1990 population of Cheyenne River was 12,218. Of this, there are 8,793 tribal members residing on the reservation and 3,425 who are non-members of the tribe.

Cheyenne River Indian Reservation members are proud ancestors of family members who participated in every major event in Lakota history including the recorded arrival of the French explorers Verendrye Brothers and the Lewis and Clark Expedition; 1854 Grattan Incident; 1851 and 1868 Fort Laramie Treaty conferences; Bozeman Trail Wars (including the 1866 Fetterman Fight); 1867 Wagon Box Fight; 1867 Hayfield Fight; 1876 Battle of the Little Bighorn; 1876 Slim Buttes and American Horse killing; 1876-77 Trek to Canada and safety with Sitting Bull, Hump, and other bands; April-May 1877 surrenders of Touch the Cloud, Big Foot, Hump, Crazy Horse, and Lame Deer; September 5, 1877 Crazy Horse killing at Fort Robinson; 1877 Allotment Act and Reservation Period beginning; 1890 Sitting Bull killing at Standing Rock; and 1890 Wounded Knee Massacre. The people still have their men and women leaders today.

Many descendants of Crazy Horse are from Cheyenne River and hold many of the secret mysteries about him which the world has yet to learn. No proven photo exists of Crazy Horse (Tasunke Witko) but he is very much a part of this book.

The Author
Donnie Sprague
Canhahake (Hump)
December, 2002

One

Wico Ahi Tokahe (Early Visitors)
1832–1833

And

Wicite Owapi Tokahe (The First Photos)
1850–1870

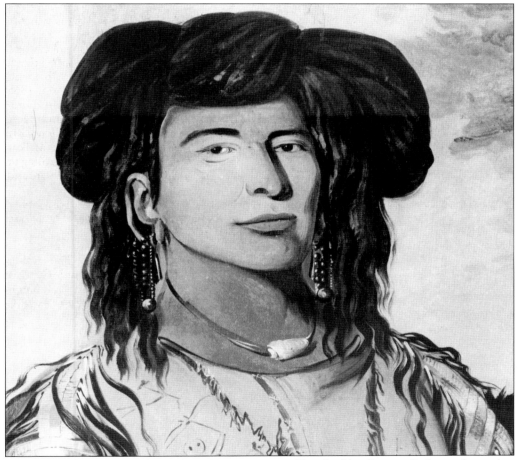

One Horn (Lone Horn), at Fort Pierre, 1832. Sketched by George Catlin and noted as "Head Chief of the Minnicoujou Division." Early family names related to the Lone Horn's include Rattling Blanket Woman (the mother of Crazy Horse), Crazy Horse, Touch the Cloud, Big Foot, Frog, Roman Nose, High Back Bone (Hump), and Black Buffalo. (Photograph courtesy of National Collection of Fine Arts, Washington D.C.)

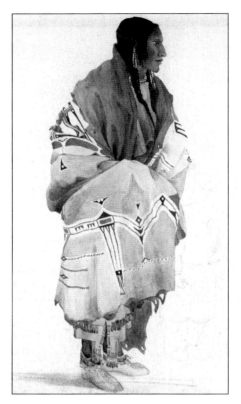

CHAN-CHA-UIA-TEUIN (WOMAN OF THE CROW NATION) AT FORT PIERRE, JUNE 1, 1833. Sketched by Karl Bodmer, she wears a "jingle dress." The box and border geometric style buffalo robe was purchased by Maximillian on this visit. Today, two similar robes are in the Maximillian Collection in Stuttgart. This woman was from the Crow Indian tribe and was likely a captive wife living among the Lakota. (Photograph courtesy of Donovin Sprague.)

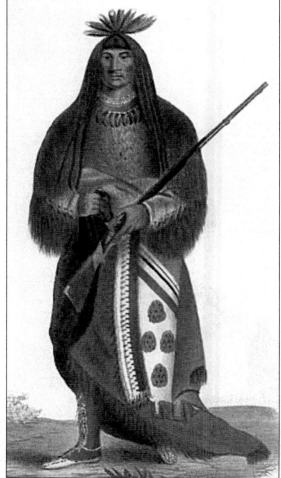

THE CHARGER (WA-NA-TA) C. 1833. This was also sketched by Swiss artist Karl Bodmer and entitled "Grand Chief of the Sioux." (Photograph courtesy of Donovin Sprague.)

BLACK ROCK, NEAR FORT PIERRE, 1832. Black Rock was a Chief of the Oohenumpa and was sketched by George Catlin. (Photograph courtesy of National Collection of Fine Arts, Washington D.C.)

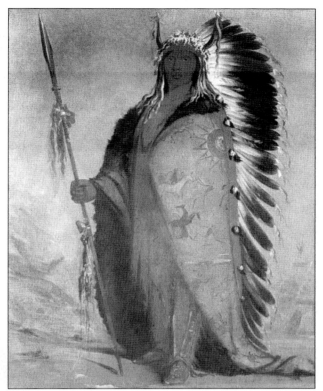

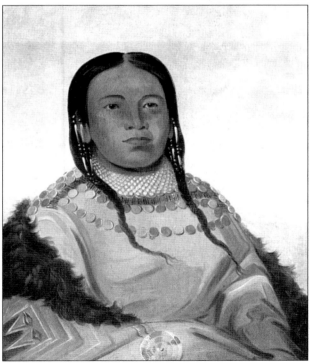

RED THING THAT TOUCHES IN MARCHING, NEAR FORT PIERRE, 1832. Sketched by George Catlin and described as Itazipco, but her father was Black Rock, Itancan (Chief) of the Oohenumpa band. (Photograph courtesy of National Collection of Fine Arts, Washington D.C.)

11

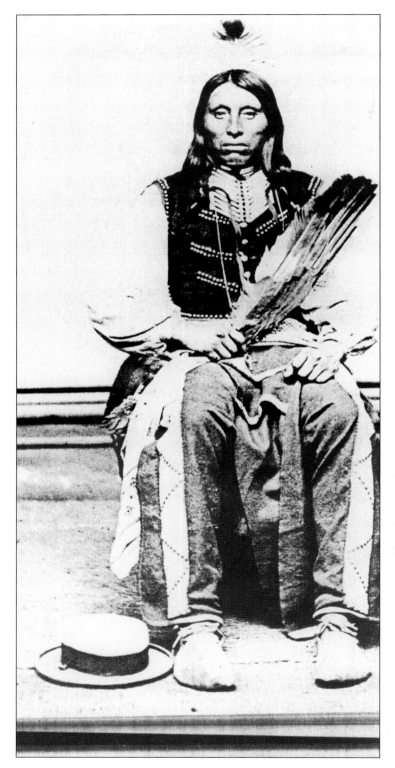

JOSEPH FOUR BEAR (OOHENUMPA). This photo was taken *c.* 1870 by B.H. Gurnsey. Four Bear (Mato Topa) was born in 1834 and married the daughter of Chief White Horse. He was a member of the Fool Soldier band that rescued the Shetak captives in 1862. He established the Four Bear Camp about 16 miles north of the agency and lived until 1909. Marcella Ryan LeBeau is a great granddaughter of Joseph Four Bear. (Photograph courtesy of Smithsonian Institute.)

THE FLYING BIRD (CAH-LAH-TA A-KE-AH), 1860s. Oohenumpa Chief. (Photograph courtesy of Peabody Museum of Natural History, Yale University.)

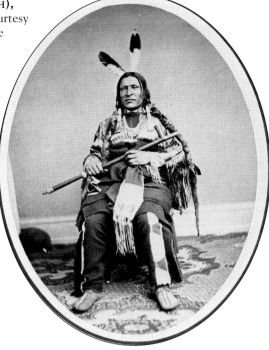

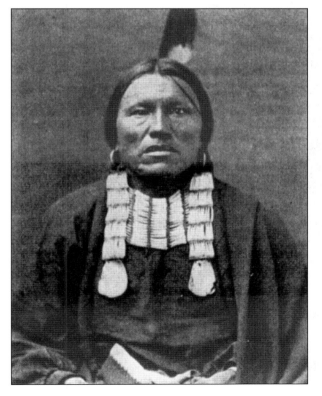

HIGH BEAR, IN WASHINGTON D.C., 1877. This Itazipco was also known as Tall Bear. An ally of Touch The Cloud, High Bear died at Cheyenne River Agency in 1910. (Photograph courtesy of West Point Military Academy Library.)

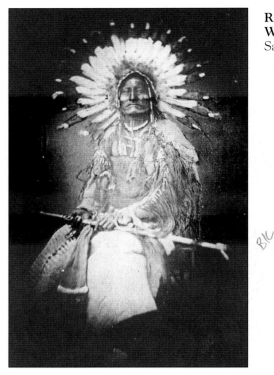

RED PLUME, AT DELEGATION TRIP TO WASHINGTON D.C., 1851-52. He was a Siha Sapa. (Courtesy of Donovin Sprague.)

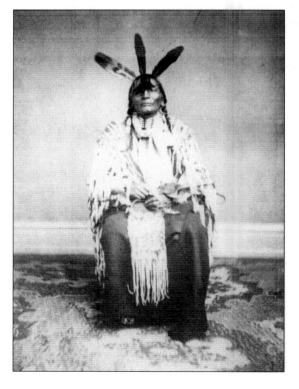

FIRST TO KILL (TOHAHEYA KTE), 1867. This Minnicoujou was photographed by A. Zeno Shindler, Washington D.C. (Photograph courtesy of Smithsonian Institute.)

RED FEATHER. This photo was taken around the 1870s. Red Feather was a Chief (Itancan) of his Itazipco band. (Photograph owned by the Smithsonian Institute.)

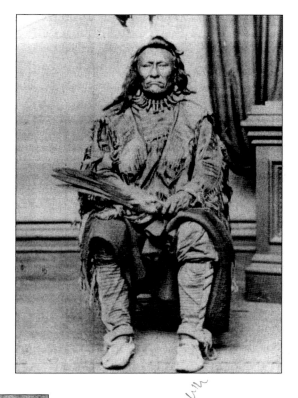

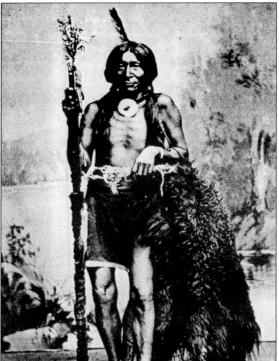

TALL BEAR. Tall Bear was a Minnicoujou. This date of this photo with studio backdrop is unknown. (Photograph courtesy of Donovin Sprague.)

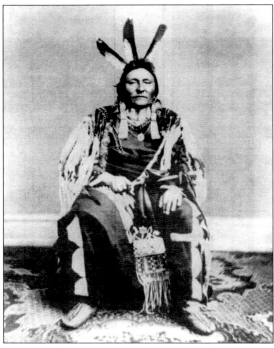

YELLOW HAWK (CE-TAN-ZA), AT WASHINGTON D.C., IN 1867. This Itazipco was photographed by A. Zeno Shindler. (Photograph owned by the Smithsonian Institute.)

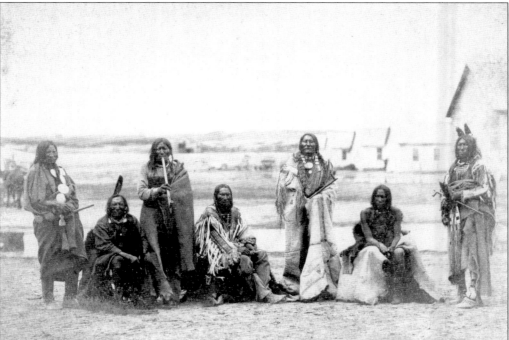

LAKOTA AND CHEYENNE ITANCAN (CHIEFS), AT FORT LARAMINE, 1868. Pictured from left to right are Spotted Tail (Sicangu), Roman Nose (Cheyenne), Old Man Afraid Of His Horses (Oglala), Lone Horn (Minnicoujou), Whistling Elk (Lakota), Pipe On Head (Lakota), and Slow Bull (Oglala). (Postcard courtesy of Donovin Sprague.)

Two

MAKA BLU WAKPA MAKOCE
(Powder River County)
FETTERMAN OKICIZE (Fetterman Fight)
CANPAGMIYANPI OKICIZE (Wagon Box Fight)
MAGA WAKPA OKICIZE (Hayfield Fight)
SICANGU OKICIZE (Battle Of The Rosebud)
PEJI SLA OKICIZE
(Greasy Grass-Battle Of The Little Big Horn)

LODGE RIDGE TRAIL, BY FORT PHIL KEARNY. This view is looking north from where Fort Phil Kearny once stood. The figures on the hill depict the location where Captain Fetterman and his men had orders not to pursue Indians over Lodge Trail Ridge. He disobeyed these orders on December 21, 1866, and all of his soldiers perished following a Lakota decoy trap. (Photograph courtesy of Donovin Sprague.)

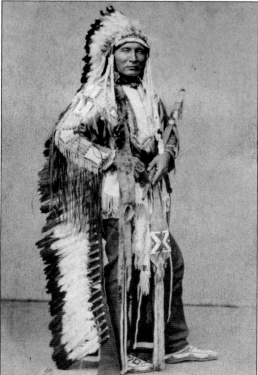

SITE OF WAGON BOX FIGHT. This site is near Fort Phil Kearny on the edge of present-day Story, Wyoming. The battle took place on August 2, 1867. On the signs, visitors read that Crazy Horse and Hump led their warriors out of the Big Horn Mountains nearby for an attack on soldiers on a wood gathering detail. U.S. soldiers circled their wagons together and held off the warriors with their new repeating arms rifles. (Photograph courtesy of Donovin Sprague.)

TOUCH THE CLOUD (MAHPIYA ICAHTAGYA). This photo was taken by Julie Ulke, 1877. This Minnicoujou Chief (Itancan) was a first cousin to Chief (Itancan) Crazy Horse and was described as the seven-foot tall bodyguard of Crazy Horse. (Postcard courtesy of Donovin Sprague.)

CHIEF BIG FOOT (SI TANKA). This photo was taken by Alexander Gardner prior to 1877. It was said that this Minnicoujou received the name Big Foot when the shoes he was issued at the agency were too big for him. (Photograph courtesy of Smithsonian Institute.)

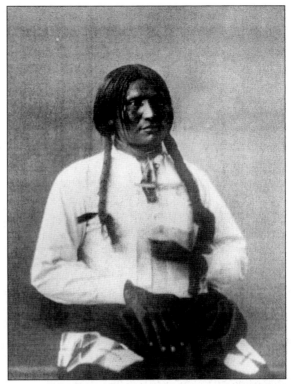

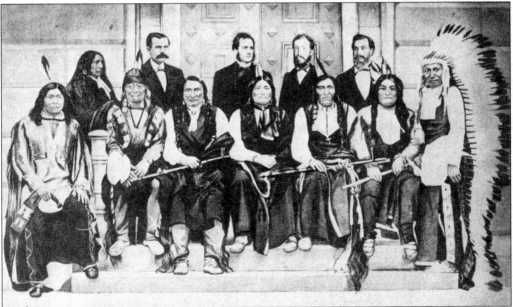

DELEGATION OF LAKOTA INDIANS, AT WASHINGTON D.C., 1875. Pictured from left to right are Rattling Ribs, Red Cloud (Oglala), Mandan (Oohenumpa), Lone Horn (Minnicoujou), Spotted Tail (Sicangu), Little Wound (Oglala), Black Bear (Lakota), and Swan (Minnicoujou). (Photograph courtesy of Donovin Sprague.)

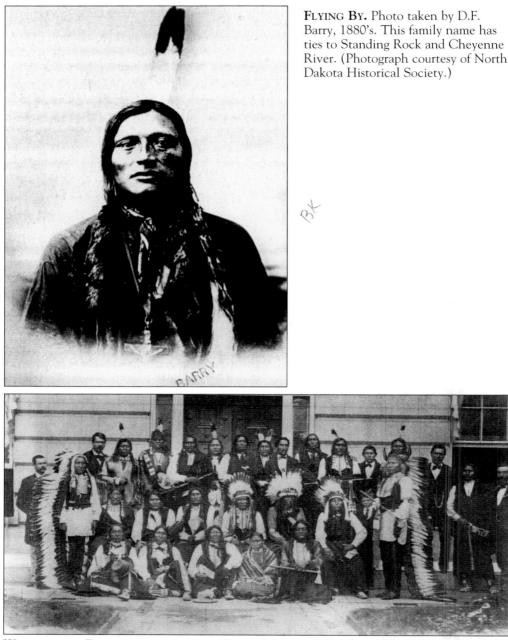

FLYING BY. Photo taken by D.F. Barry, 1880's. This family name has ties to Standing Rock and Cheyenne River. (Photograph courtesy of North Dakota Historical Society.)

WASHINGTON DELEGATION, TAKEN AT FORT BENNETT, MAY-JUNE 1875. Pictured from left to right are: (back row) Major Bingham (to the left of the man in the headdress), William Felder (interpreter), Rattling Ribs, Long Mandan, Lone Horn, Sitting Bull (not the Hunkpapa leader), Spotted Tail, unidentified, Mark Wells (interpreter), Swift Bear, Little Wound, two unidentified men, Billy Garnette, unidentified, Agent Saville; (middle row) Little Swan, Charger?, Slow Bull?, Spotted Elk (aka Si Tanka-Big Foot), the remaining five in this row are unidentified; (front row) Unidentified, American Horse or Bad Wound?, Wife of Bad Wound-Rosie Tree Top?, Four Bear?, Black Bear or Red Dog?. (Photo courtesy of Donovin Sprague.)

SCORCHED LIGHTNING (UNDATED). This Minnicoujou has a grizzly bear necklace. (Photograph courtesy of Donovin Sprague.)

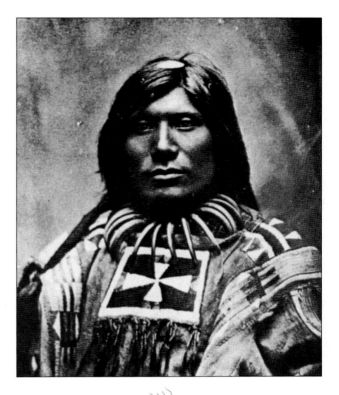

RED HORSE (TASUNKE LUTA), TAKEN BY D.F. BARRY, C. 1890. Red Horse was a Minnicoujou. He fought at the Little Big Horn and in 1881 created 41 ledger drawings depicting the battle. (Postcard courtesy of Donovin Sprague.)

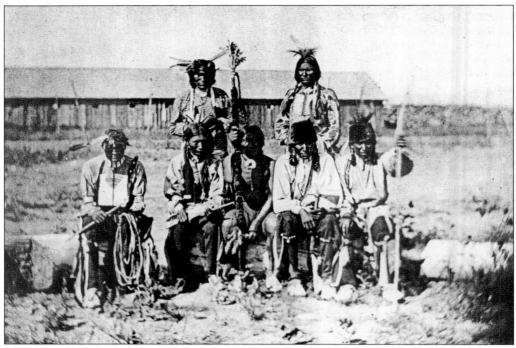

CHIEF HUMP (MINNICOUJOU), WITH HEAD WARRIORS, UNDATED. Hump is in the center, seated, and others are unidentified. (Photograph courtesy of Donovin Sprague.)

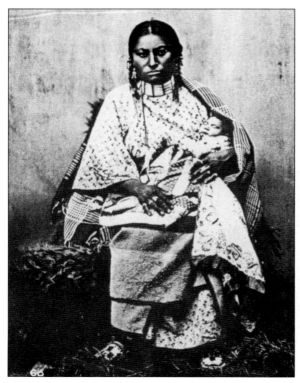

MRS. HUMP, TAKEN IN JANUARY 1880. This Minnicoujou wife of Hump is shown with her baby. (Photograph courtesy of Donovin Sprague.)

TOUCH THE CLOUD (MAHPIYA ICAHTAGYA), UNDATED. This Minnicoujou was from the Lone Horn family and was present during the killing of Crazy Horse, staying with him until he died. He could offer no protection since both were under surrender and disarmed. Touch The Cloud insisted that the dying body of Crazy Horse be moved from the guardhouse where he was stabbed at Fort Robinson to the adjutant's office and the request was granted. (Photograph courtesy of the Nebraska State Historical Society.)

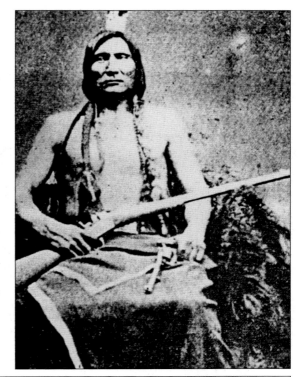

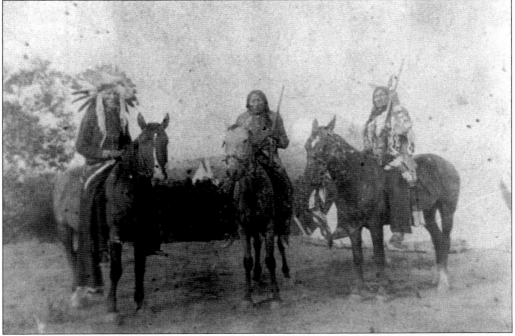

BLACK EAGLE (LEFT), HUMP (CENTER), HIS HORSE LOOKING (RIGHT), TAKEN C. 1885. Hump is holding a Winchester "Yellowboy" rifle. All are Minnicoujou with a view of a camp in the background. (Photograph courtesy of Donovin Sprague.)

23

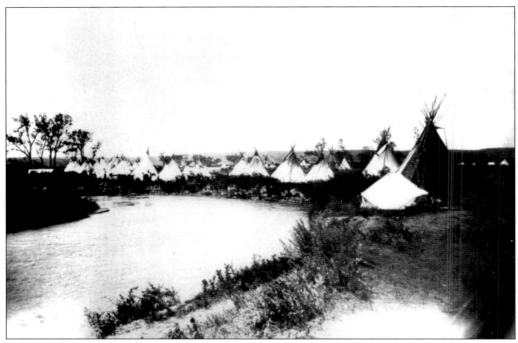

LAKOTA CAMP ON LARAMINE RIVER, 1877. This river is in southeastern Wyoming and comes out of the North Platte River from Nebraska. (Photograph courtesy of Donovin Sprague.)

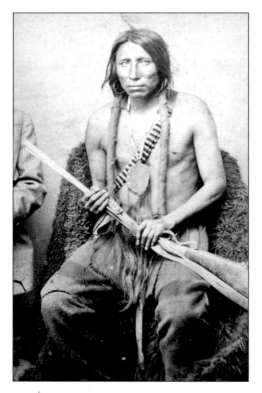

SPOTTED EAGLE, PHOTO THOUGHT TO HAVE BEEN TAKEN BETWEEN 1870-1880. This Itazipco was credited as being a head Chief (Itancan) of Sitting Bull's during the late Indian war. (Photograph courtesy of the Denver Public Library.)

24

MARTIN CHARGER, UNDATED. Martin Charger was a member of the Fool Soldiers Band that rescued white women and children taken at Lake Shetek during the Minnesota Uprising of 1862. The Itazipco Itancan established his band at Cheyenne River Agency. (Photograph courtesy of South Dakota State University.)

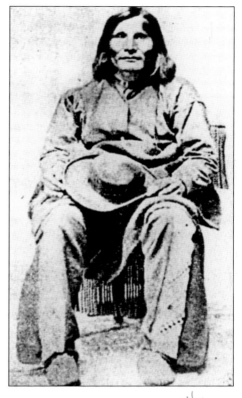

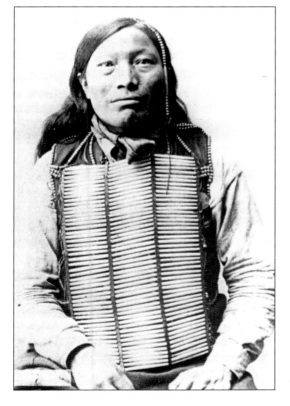

ONE BULL, PHOTOGRAPHED BY L.W. STILWELL, 1880S. One Bull, a Minnicoujou, was a brother of White Bull and nephew of Sitting Bull. One Bull lived to the age of 94. (Photograph courtesy of Nebraska State Historical Society.)

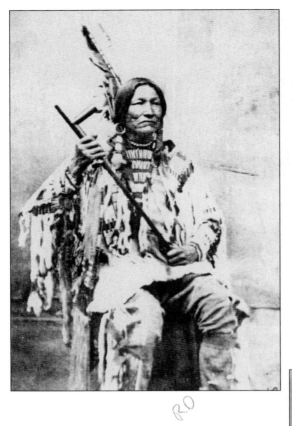

WHITE BULL (PTE SAN HUNKA), UNDATED PHOTO. He is listed as Itazipco and Minnicoujou. Being a nephew of Sitting Bull, he would also be part Hunkpapa. Dying on July 24, 1947, White Bull lived to the age of 98. (Photograph courtesy of Donovin Sprague.)

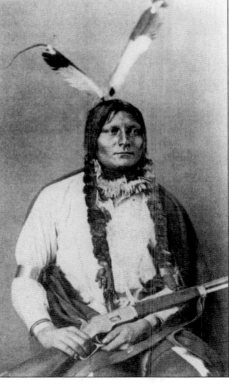

TWO CROW, TAKEN BY F. JOY HAYNES (UNDATED). He is Siha Sapa and holds the popular Winchester rifle. (Photograph courtesy of Donovin Sprague.)

ROAN BEAR (MATO-HIN-HOTA), PHOTO TAKEN BY DELANCEY GILL AT WASHINGTON D.C., 1910. He was an Oohenumpa born in 1859 and married Estella Dupris (Minnicoujou) in September of 1877. Estella was the daughter of Fred Dupris and Mary Good Elk Woman. Roan Bear joined the church and took the name Clarence Ward, working with Thomas Riggs. (Photograph courtesy of Donovin Sprague.)

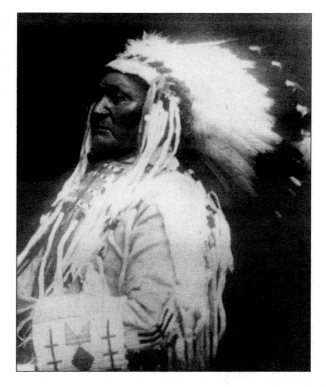

JULIA (IRON CEDAR) CLOWN, AND HUSBAND AMOS CLOWN (ITAZIPCO), IN AN UNDATED PHOTO. Julia was a sister of Crazy Horse. (Photograph courtesy of Elsie Clown Slides Off.)

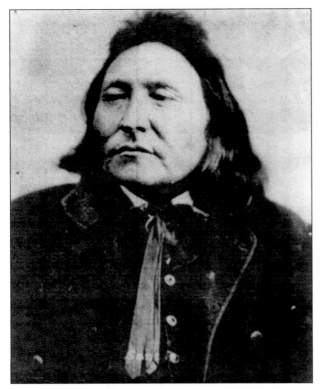

YELLOW HAWK (CE-TAN-ZA), AT WASHINGTON D.C., 1869. He is Itazipco and was photographed by either A. Zeno Shindler or Alexander Gardner. (Photograph courtesy of the Smithsonian Institute.)

SCAR LEG, A LAKOTA, IS STANDING, AND HUMP, A MINNICOUJOU, ON HORSEBACK, TAKEN IN 1906. Mrs. Mary Bagola's maiden name was Scarleg and there is a Scar Leg Crossing near the Moreau (Owl) River in the Isabel, S. D. area. (Photograph courtesy of Donovin Sprague.)

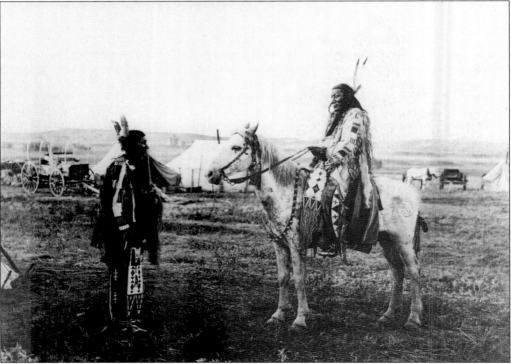

**FIRE CLOUD, PHOTOGRAPHED BY DAVID F. BARRY,
UNDATED.** Fire Cloud is a member of Siha Sapa.
(Photograph courtesy of Smithsonian Institute.)

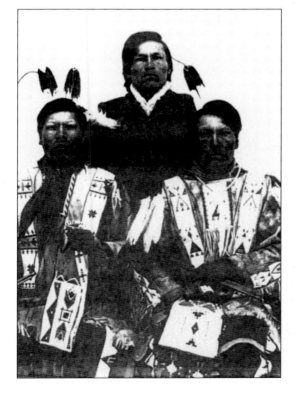

**DEWEY BEARD (IRON HAIL) (RIGHT),
AND BROTHERS JOSEPH HORN CLOUD
(CENTER), AND DANIEL WHITE LANCE
(LEFT).** Note the traditional Lakota
geometric designs. (Photograph courtesy
of Nebraska State Historical Society.)

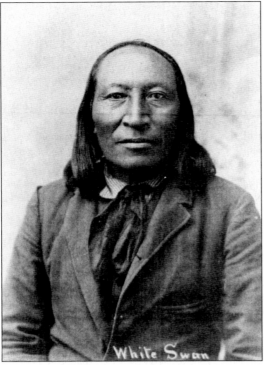

White Swan

WHITE SWAN IN AN UNDATED PHOTO. Born in 1837, this Minnicoujou fought in the Battle of the Rosebud in June 1876. He was a noted Chief (Itancan) and was assigned to Cherry Creek. He died in 1900 at Fort Bennett. (Photograph courtesy of Donovin Sprague.)

SMOKE WOMAN (MINNICOUJOU), TAKEN **c. 1900.** This is entitled "Granddaughter of a Chief." She lived at Cherry Creek. (Photograph courtesy of South Dakota Historical Society.)

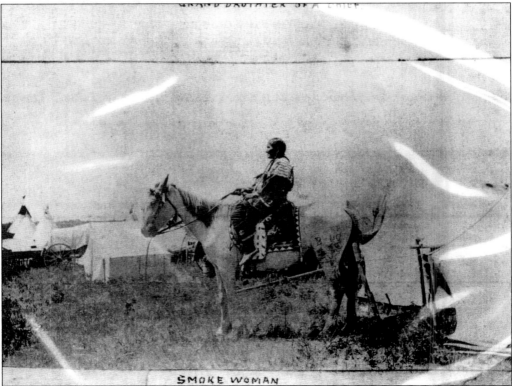

SMOKE WOMAN

CHIEF HUMP (MINNICOUJOU), AND TWO OF HIS WIVES. This photo was taken *c.* 1879 and was photographed by L.A. Huffman. Hump fought on Calhoun Hill at the Little Big Horn with Crazy Horse, Gall, and others, where he received a bullet wound in his leg. (Photograph courtesy of the National Park Service, Little Bighorn National Monument.)

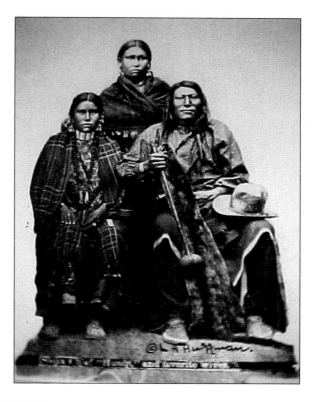

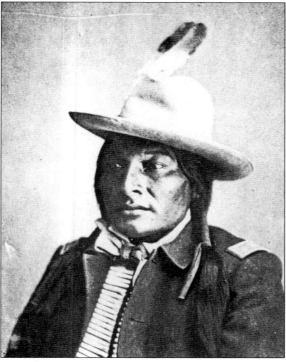

SPOTTED ELK, TAKEN IN 1878. This Minnicoujou is also known as Big Foot (Si Tanka), a Chief (Itancan) and son of Chief Lone Horn. (Photograph courtesy of Donovin Sprague.)

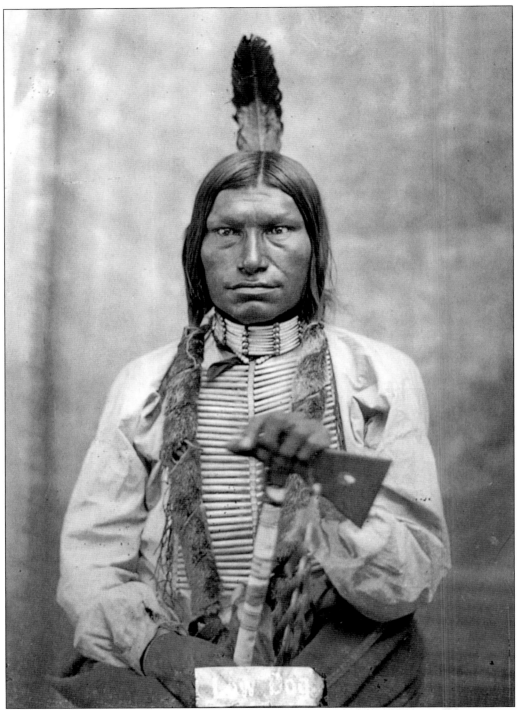

LOW DOG (OGLALA). I visited with Carideo Low Dog and his wife Estherlene of Dupree, S.D. Carideo is the Great Grandson of Low Dog. Carideo and Estherlene are members of the Cheyenne River Sioux Tribe. (Postcard courtesy of Donovin Sprague.)

HIGH BEAR (MINNICOUJOU). This photo was taken by F.A. Rinehart in 1898. It was taken as part of the Trans-Mississippi Exposition in Omaha. High Bear family descendants are Minnicoujou, Yankton, Hunkpapa, and Itazipco. (Photograph courtesy of Donovin Sprague.)

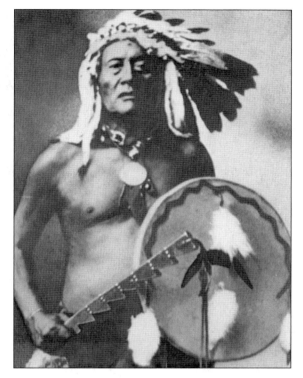

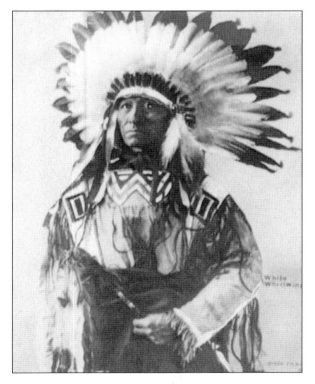

WHITE WHIRLWIND, A CHEYENNE RIVER SIOUX. This photo was taken by R.A. Rinehart in 1898 during the Trans-Mississippi Exposition. (Photograph courtesy of Donovin Sprague.)

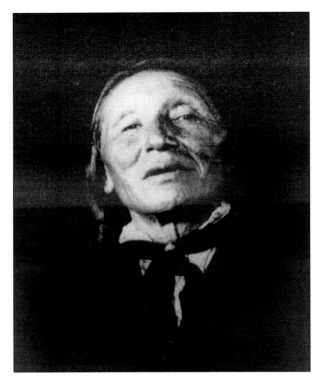

IRON LIGHTNING (WAKINYAMAZA). This photo was taken by DeLancey Gill, January 17, 1906. This Minnicoujou was born in 1850 and the community of Iron Lightning is named for him. This photo is sometimes mistaken as a photo of Hump. (Photograph courtesy of the Smithsonian Institute.)

FRED DUPRIS, PETE DUPRIS, AND MARY GOOD ELK WOMAN. Fred's family were French traders and ranchers. He married Good Elk Woman, a Minnicoujou from Cherry Creek, and in the center is Pete, one of the children. Their original name was Dupui and later the names Dupuis, Dupris, and Dupree were also used. The town of Dupree is named for them; the town was built on their land. Fred is one of six people across the United States credited for saving the buffalo from extinction. The original Dupree buffalo herd was sold to Scotty Philip and many went to Custer State Park in South Dakota to begin their large herd. Fred and Mary are the author's great great great grandparents. (Photograph courtesy of South Dakota Historical Society.)

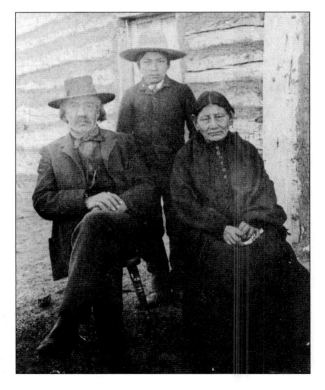

TALL MANDAN (MINNICOUJOU), UNDATED. (Postcard courtesy of Donovin Sprague.)

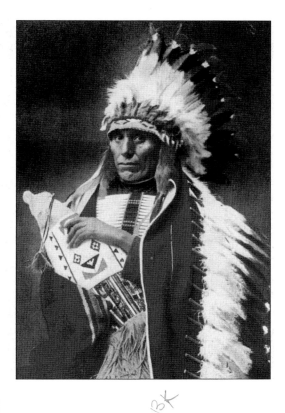

CHIEF RED FOX (UNDATED PHOTO). Born at Thunder Butte, Dakota Territory on June 11, 1870, he was a nephew of Crazy Horse and traveled with Buffalo Bill's Wild West Show. (Postcard courtesy of Donovin Sprague.)

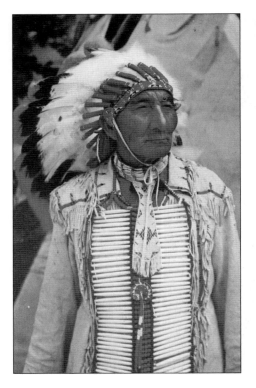

CHIEF KNIFE (MINNICOUJOU), NOT DATED. (Postcard courtesy of Donovin Sprague.)

CHIEF JOHN GRASS PHOTOGRAPHED BY DELANCEY GILL, 1912. He was also known as Charging Bear and listed as Siha Sapa but also has ties to the Hunkpapa. (Photograph courtesy of Donovin Sprague.)

SOLOMON YELLOW HAWK (ITAZIPCO). This photo was taken in Pierre, South Dakota, in 1909. (Photograph courtesy of Ruby Marshall and Edith Traversie.)

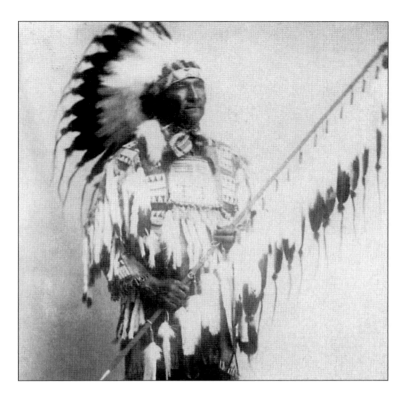

JULIA YELLOW HAWK, UNDATED. In this picture she is 90 years of age. Mother of Solomon Yellow Hawk, Julia was a white woman rescued as a baby from a destroyed village by the Yellow Hawk family and raised by them. She married a son of the Yellow Hawks. (Photograph courtesy of Ruby Marshall and Edith Traversie.)

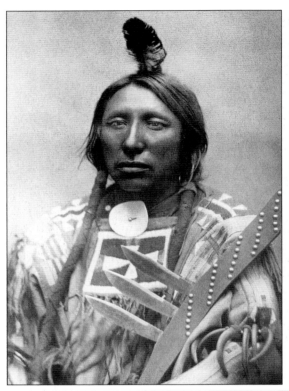

SPOTTED EAGLE (WA-MA-LAHA-LISCA), TAKEN BY L. A. HUFFMAN, 1880. This Chief (Itancan) took his Itazipco band to Canada after the Battle of the Little Big Horn and later surrendered to General Miles in 1880. (Postcard courtesy of Donovin Sprague.)

DONOVIN SPRAGUE (MINNICOUJOU). The author is pictured here speaking at the 125th anniversary of the Battle of the Little Big Horn site in Montana. This photo was taken June 25, 2001. Partially hidden behind him are Vernon Robertson and A. Gay Kingman, both Cheyenne River Lakotas. Behind the U.S. flag is Last Stand Hill. (Photograph courtesy of Donovin Sprague.)

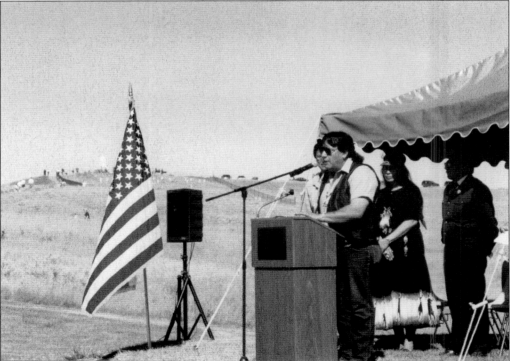

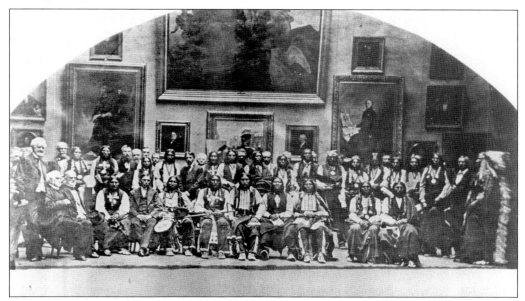

DELEGATION OF INDIANS AT WASHINGTON D.C., OCTOBER 30, 1877. This photo was taken at the Corcoran Gallery of Art. Pictured, upper row, from left to right are: Big Road, Iron Crow, Little Big Man, Yellow Bear, Black Crow, Red Cloud, Spotted Tail, Spotted Tail Jr., Swift Bear, White Tail, Ring Thunder, Hollow Horn, Little Hawk, Young Man Afraid of His Horses, Good Voice, Touch The Cloud; second row, He Dog, Billy Hunter, American Horse, Little Wound, Black Coal, Friday, Sharp Nose, Beads, and Bear. The non-Indians pictured are: Mr. A. Hyde, Mr. W.W. Corcoran, Captain Nicholson, Dr. J.C. Hall, Gen. Crook, Lieutenant Clark. The last two names are unclear. (Photograph courtesy of Donovin Sprague.)

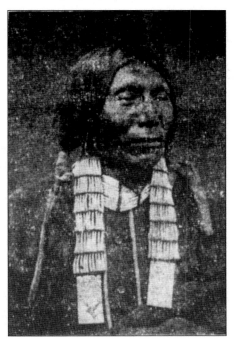

TOUCH THE CLOUD (MINNICOUJOU), UNDATED.
(Photograph courtesy of Donovin Sprague.)

CHIEF HUMP'S MINNICOUJOU CAMP AT CHERRY CREEK, SOUTH DAKOTA, C. 1900. (Photograph courtesy of Denver Public Library.)

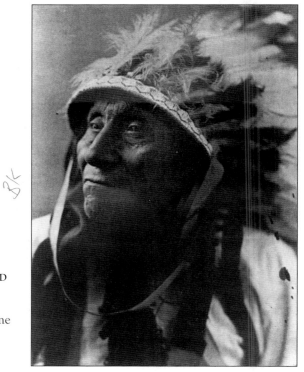

STANDING BEAR, TAKEN BY HEYN AND MATZEN OF OMAHA, C. 1900. He is a Minnicoujou who, at the time of this photo, was about 41 years old. The name Standing Bear is common in other Lakota bands as well. (Photograph courtesy of the Smithsonian Institute.)

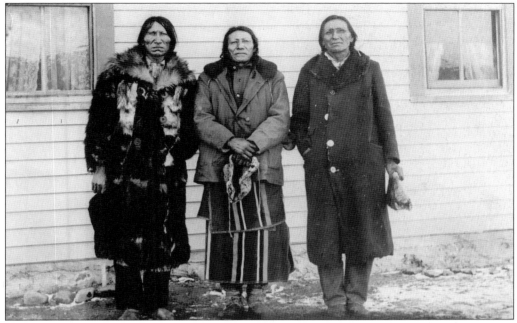

CHIEFS BLACK EAGLE, HUMP, AND IRON LIGHTNING, C. 1904. This photo was taken by P.H. Kellogg. The community of Iron Lightning is named for this Iron Lightning. There are three Hump Flats named for Hump in South Dakota. (Photograph courtesy of Donovin Sprague.)

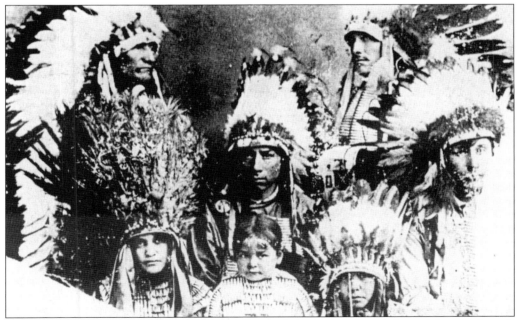

CHEYENNE RIVER RELATIVES, UNDATED. Pictured, back row, from left to right, are: Joseph White Bull, Narcisse Red Fox, Thomas Blue Eyes, and Alfred Fisherman; front row: Lillie Carlin (Briggs), Mazie Blue Eyes (In The Woods), and Rosa Ward (Circle Eagle). (Photograph courtesy of South Dakota State Historical Society.)

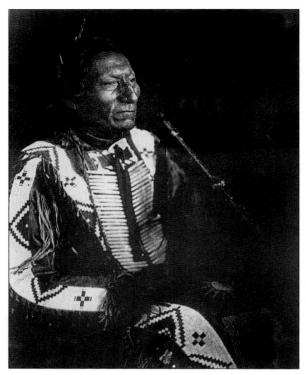

WHITE BULL (PHOTO UNDATED).
Listed here as a Minnicoujou, White
Bull's father was Makes Room and
his mother was Good Feather, a
sister of Sitting Bull. (Photograph
courtesy of American Museum of
Natural History.)

**WHITE BULL (ITZAZIPCO) AND
HOLE IN THE CLOUD (LAKOTA),
UNDATED.** White Bull is pictured
here mounted on the horse and Hole
In The Cloud is holding the U.S.
flag (Photograph courtesy of
Donovin Sprague.)

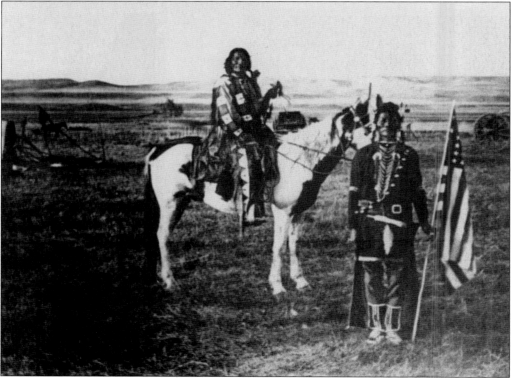

RED BLANKET, TAKEN C. 1880-1890. The back of this image reads "...Cheyenne Agency, S.D." He was later a U.S. scout at Cheyenne River. (Photograph courtesy of Denver Public Library.)

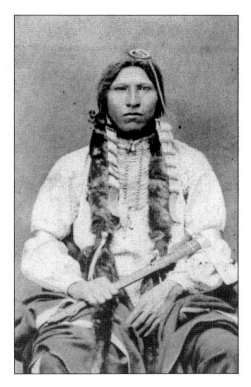

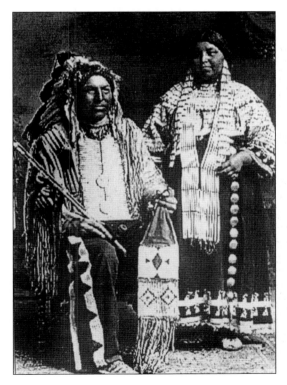

JOHN (YELLOW HAWK) SAUL AND HIS WIFE (ITAZIPCO) IN AN UNDATED PHOTO. John was the uncle of Ruby Marshall and Edith Traversie. (Photograph courtesy of Ruby Marshall and Edith Traversie.)

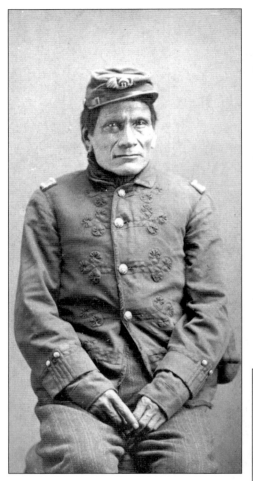

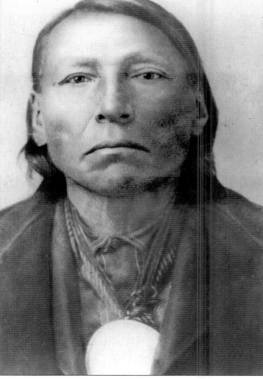

SANS ARC JOHN, PHOTO DATED 1870-1880. He is an Itazipco and his name is a nickname. Sans Arc is the French reference to the Itazipco. (Photograph courtesy of the Denver Public Library.)

CHIEF HUMP (MINNICOUJOU), WEARING A PRESIDENTIAL PEACE MEDAL IN AN UNDATED PHOTO. Chief Hump is the author's great, great grandfather. (Photograph courtesy of Donovin Sprague.)

CORN (WA-KMA-HE-ZA), LAKOTA, TAKEN IN 1910 BY DeLANCEY GILL. (Photograph courtesy of Donovin Sprague.)

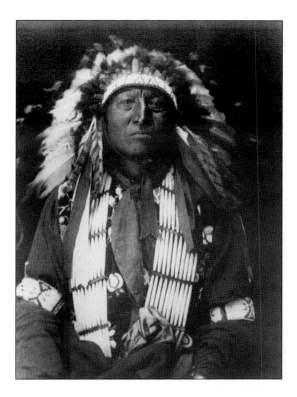

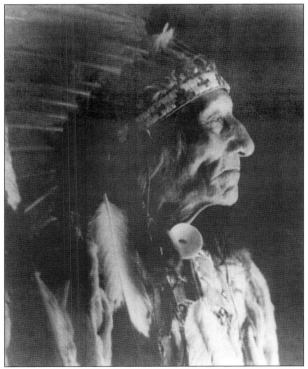

WHITE BULL, A CHIEF OF THE ITAZIPCO AND NEPHEW OF SITTING BULL. The photo was taken by Frank Fiske in Fort Yates, North Dakota, but carries no date. He was also listed as Lazy White Bull. Coming down from the north to settle at Cheyenne River, he also has roots among the Minnicoujou and Hunkpapa. (Photograph courtesy of South Dakota State Historical Society.)

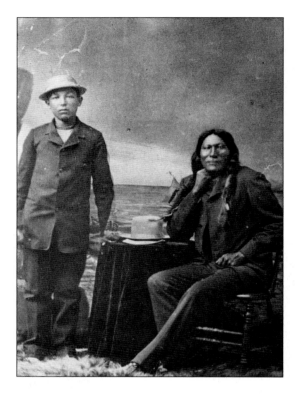

ANDREW TRAVERSIE (LAKOTA) AND HUMP (MINNICOUJOU) IN WASHINGTON D.C., UNDATED. In this photo, Andrew is 16 years old and is serving as language interpreter for Hump. Andrew was attending boarding school at the time. (Photograph courtesy of Donovin Sprague.)

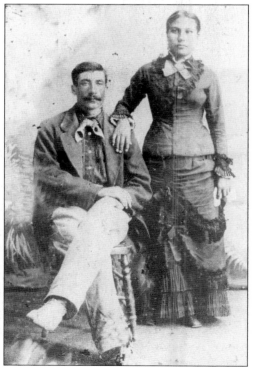

FELIX BENOIST SR. (FRENCH/MINNICOUJOU) AND MARY "VIRGIN" POOR BEAR (MINNICOUJOU), PRIOR TO 1890. Felix was later married to Cora Cow in 1892. Born in 1857, he died on November 29, 1929. He also served as a Lakota interpreter. This is the author's great grandparents. Felix attended Hampton Institute from 1879-1881, being among the first of American Indians to attend this new school. (Photograph courtesy of Mildred Benway.)

Three
PTE HINCALA WAKAN CANUMPA
(Sacred Buffalo Calf Pipe)

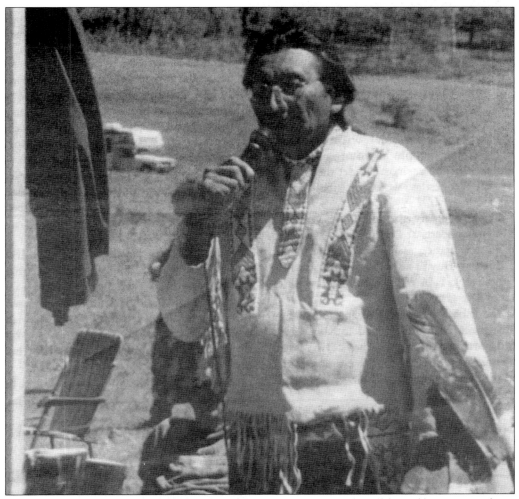

ARVOL LOOKING HORSE. He is the present keeper of the Sacred Buffalo Calf Pipe. Here he is speaking at World Peace and Prayer Day. (Photo courtesy of Donovin Sprague.)

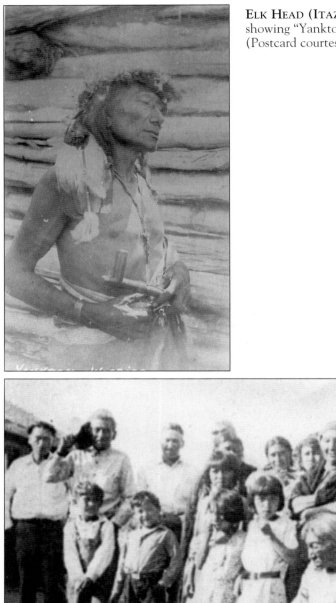

ELK HEAD (ITAZIPCO), UNDATED. A label showing "Yankton Warrior" is incorrect. (Postcard courtesy of Donovin Sprague.)

MARTHA BAD WARRIOR AND RELATIVES AT GREEN GRASS, UNDATED. Martha Bad Warrior is seated in the front with a Pipe. Children, pictured from left to right, front row, are: Garnette Black Bear, Milton Elk Head, unidentified, and Marion High Elk ?; back row; Henry Janis, Eli, Simon, Elk Head, Annie Yellow Hawk, unidentified, Lucy ?, Nancy Elk Head, and Ella Bad Warrior. Elk Head is partially hidden. The woman in front of Elk Head is unknown. The person second from the right in back is also hidden and unidentified. Martha Bad Warrior was the only woman who was keeper of the Sacred Pipe. (Photograph courtesy of South Dakota State Historical Society.)

Elk Head (Itazipco), Photo taken by Edward S. Curtis, 1907. Elk Head is pictured with a Canumpa (Pipe) and storage bundles on a tripod. (Photograph courtesy of Smithsonian Institute.)

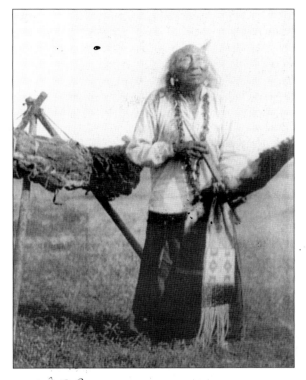

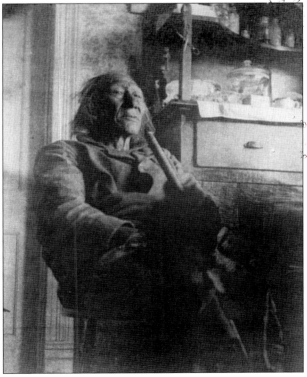

Elk Head (Itazipco), Undated. Elk Head was Keeper of the Sacred Buffalo Calf Pipe. The author identified this photo for the South Dakota State Archives. (Photograph courtesy of South Dakota State Historical Society.)

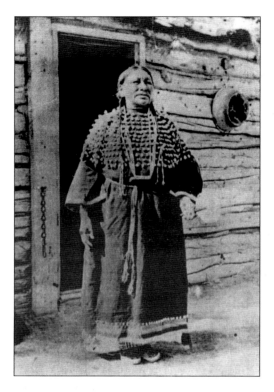

MARTHA BAD WARRIOR, UNDATED. Martha was keeper of the Sacred Pipe at Green Grass. (Photograph courtesy of the Smithsonian Institute.)

MAP OF THE LAKOTA RESERVATIONS, SOUTH DAKOTA, 1891. On Cheyenne River it shows the camps of Hump, Touch The Cloud, Big Foot, and Narcisse Narcelle, all in the same area. To the northeast are the camps of Cook, Corn, and White Swan. (Map courtesy of Donovin Sprague.)

Four

WANAGI WACIPI (Ghost Dance)
AND
CANK'PE OPI (Wounded Knee)

The Wounded Knee Massacre was on December 29, 1890. December is the Moon When the Deer Shed Their Horns (Wanicokan Wi). This event is well known and the subject of many books.

The fact that most of those killed in the massacre were from the Cheyenne River Indian Reservation is not well known. The northern Lakota bands including the Hunkpapa Lakota had traveled from Standing Rock Indian Reservation to the Cheyenne River Indian Reservation where Big Foot's (Si Tanka) band had the largest following of the Ghost Dance religion. This was following the killing of Sitting Bull on December 15, 1890 during an arrest at his home. With Big Foot, the northern Lakota would journey south to the Pine Ridge Indian Reservation. Soldiers would pursue them and they surrendered near the base of Porcupine Butte. They were taken about a mile southwest to the area of Wounded Knee Creek when shots broke out during disarming the Lakota. About 356 band members had been intercepted by U.S. Major Whitside. Colonel Forsyth began disarming the band when the massacre started. About 300 of the band were killed. Thirty solders also died, many in their own crossfire. Lakota women and children were found gunned down two miles away during their flight.

On January 3, 1891, after a raging blizzard, a burial party dug the mass grave and stacked the frozen bodies inside the pit without ceremony. The Wounded Knee Massacre marks the ending of America's Indian Wars, just over 100 years ago.

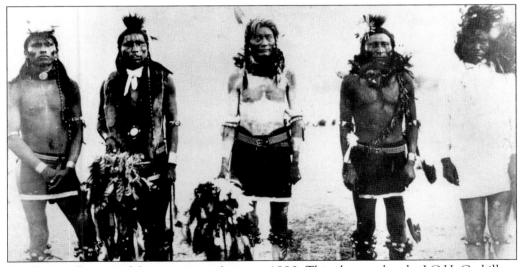

BIG FOOT'S BAND OF MINNICOUJOU, AUGUST 1890. This photo, taken by J.C.H. Grabill on the Cheyenne River, features, from left to right, Bear-That-Runs-And-Growls, Warrior, One-Tooth-Gone, Sole (bottom of foot), and Makes It Long. The picture was taken at a grass dance and most of these men were killed four months later at the Wounded Knee Massacre. (Photograph courtesy of Donovin Sprague.)

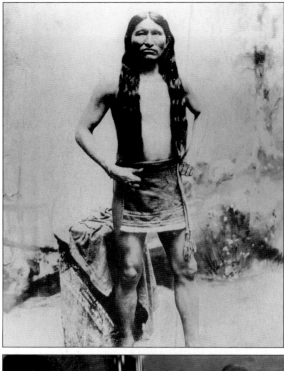

KICKING BEAR (MINNICOUJOU) IN AN UNDATED PHOTO. (Photograph courtesy of Donovin Sprague.)

LAKOTA DELEGATION TO WASHINGTON D.C., TAKEN BY THOMAS WILLIAM SMILLIE, OCTOBER 15, 1888. Spotted Elk, aka Big Foot (Si Tanka), a Minnnicoujou, is in the front row, second from left holding the Pipe. (Photograph courtesy of Donovin Sprague.)

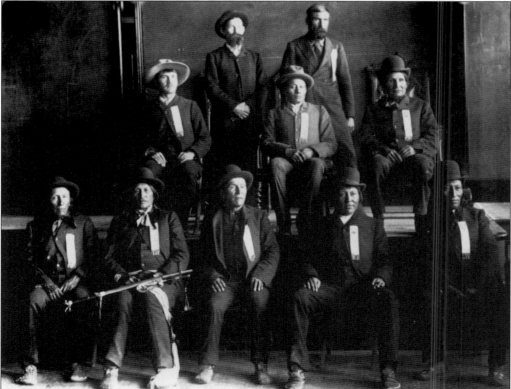

CHIEF BIG FOOT (SI TANKA), UNDATED.
This Minnicoujou was also known as
Spotted Elk. In the studio many posed with
Christian crosses around their necks.
(Photograph courtesy of Donovin Sprague.)

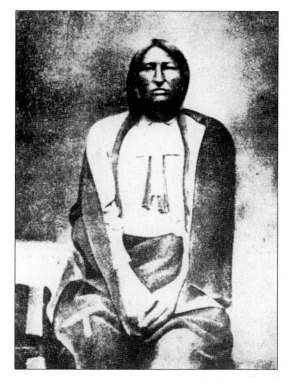

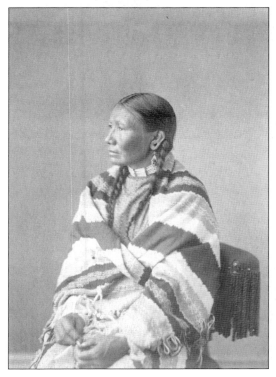

WHITE HAWK, TAKEN IN 1872. This
Minnicoujou woman was one of the wives
of Big Foot (Si Tanka). (Photograph
courtesy of Donovin Sprague.)

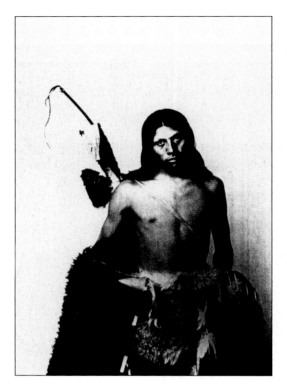

WILLIAM FROG (GNASKA), TAKEN BY HEYN AND MATZEN IN OMAHA, 1898. This photograph was likely taken at the Indian Congress of the 1898 Trans-Mississippi and International Exposition. This man was a brother of Big Foot (Si Tanka). (Though non-Indians would refer to William Frog as a half brother of Big Foot, Lakotas do not use the term, therefore he is a brother.) (Photograph courtesy of the Library of Congress.)

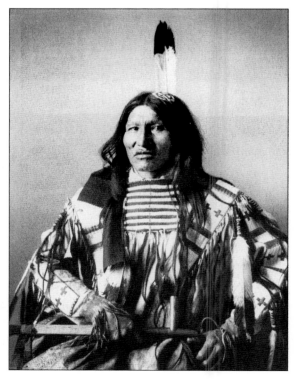

KICKING BEAR (MINNICOUJOU). This photo was taken by William Dinwiddle in 1896. Kicking Bear and Short Bull were leaders of the Ghost Dance religion. (Postcard courtesy of Donovin Sprague.)

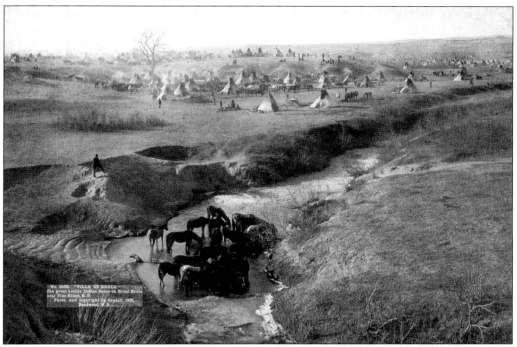

LAKOTA CAMP NEAR PINE RIDGE. This 1891 photo by C.H. Grabill was taken following the Wounded Knee Massacre. (Postcard courtesy of Donovin Sprague.)

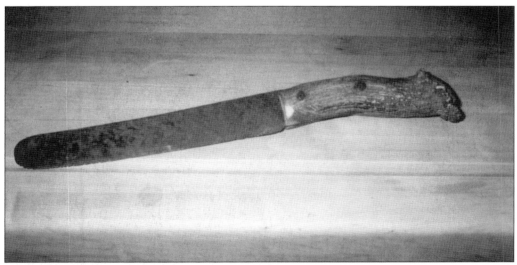

WOUNDED KNEE KNIFE. This is a metal blade knife with a deer horn handle found on the site of the Wounded Knee Massacre of 1890. It was acquired by Donovin Sprague for the Crazy Horse Memorial in South Dakota, and donated by Richard and Lorraine Turnipseed. (Photograph courtesy of Donovin Sprague.)

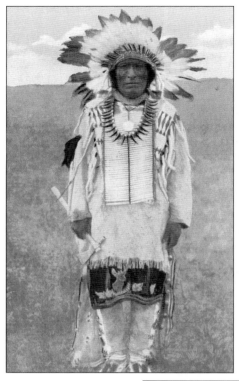

DEWEY BEARD (MINNICOUJOU), UNDATED. Dewey Beard was also known as Iron Hail and was a survivor of both the Battle of the Little Big Horn and the Wounded Knee Massacre. (Postcard courtesy of Donovin Sprague.)

FIVE GENERATIONS. Pictured from left to right are Emma (Mrs. Guy) Buffalo, Grandson Danny Buffalo, Alice (Ghost Horse/War Bonnet/Charging Cloud) Dog Arm; Alice (Mrs. Jacob) Widow, and Dennis Buffalo (standing in the back). This photo is undated. There are five generations featured in this photo. Alice is a Wounded Knee survivor. Her husband, Ghost Horse, and son were killed at Wounded Knee. (Photograph courtesy of South Dakota State Historical Society.)

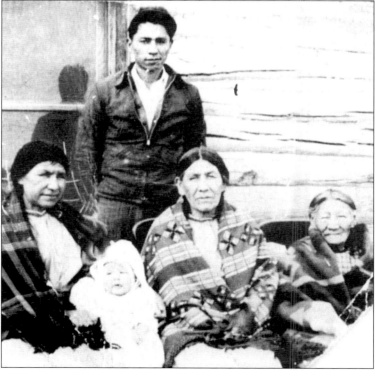

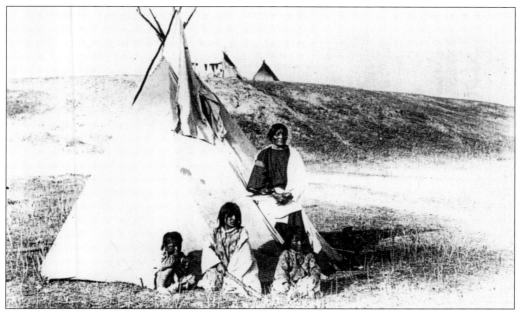

BLUE WHIRLWIND AND CHILDREN. Although she was wounded fourteen times, Blue Whirlwind survived the Wounded Knee Massacre. Two of her sons were also wounded. Her husband, Spotted Thunder, was killed. This photo is undated. (Photograph courtesy of the Nebraska Historical Society.)

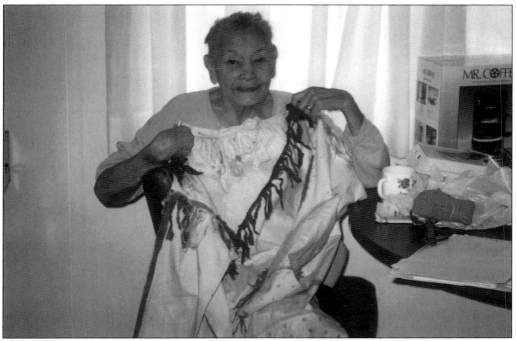

WOUNDED KNEE GHOST DANCE SHIRT. Edith Hein, a Lakota, is shown with an 1890 Ghost Dance Shirt which belongs to her family. (Photograph courtesy of Donovin Sprague.)

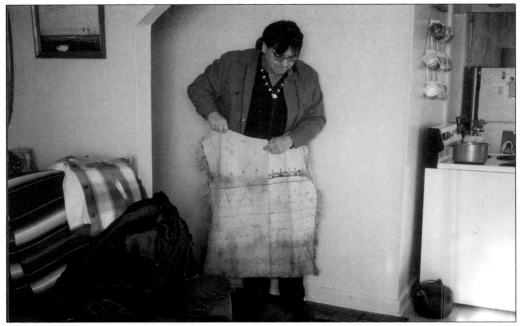

WOUNDED KNEE GHOST DANCE LEGGINGS. Donovin Sprague (Minnicoujou) is shown with 1890 Ghost Dance leggings. Made of burlap from which flour rations were packed, the darkened area at the bottom is from wading through snow which stained them. The leggings belong to the family of Edith Hein. The wearer of these leggins survived. (Photograph courtesy of Donovin Sprague.)

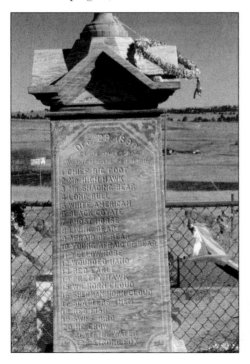

1890 WOUNDED KNEE MASSACRE MARKER. Located at the mass grave site, only 22 names were listed, mostly heads of households. Many more died. (Photograph courtesy of Donovin Sprague.)

DEWEY BEARD (MINNICOUJOU). This Canumpa (Pipe) is now in the Indian Museum of North America at Crazy Horse Memorial in South Dakota. It was donated by Bob Lee. (Photograph courtesy of Donovin Sprague.)

ALICE WHITE WOLF, A CHEYENNE RIVER SURVIVOR OF THE WOUNDED KNEE MASSACRE, 1890. (Photograph courtesy of Jim Gillihan.)

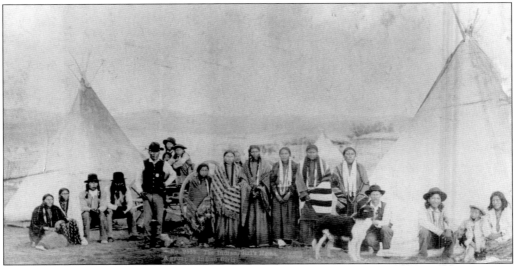

BIG FOOT'S CAMP OF MINNICOUJOU C. 1890. This photo was taken by Grabill. (Photograph courtesy of Donovin Sprague.)

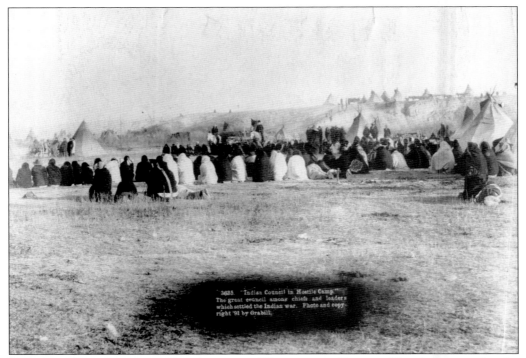

WOUNDED KNEE SURVIVORS SHOWN IN THE WAKE OF THE BATTLE. The photo was taken by Grabill in January of 1891. (Photograph courtesy of Donovin Sprague.)

Five

WAKPA WASTE OWAKPAMNI
(Good River/Cheyenne Agency)

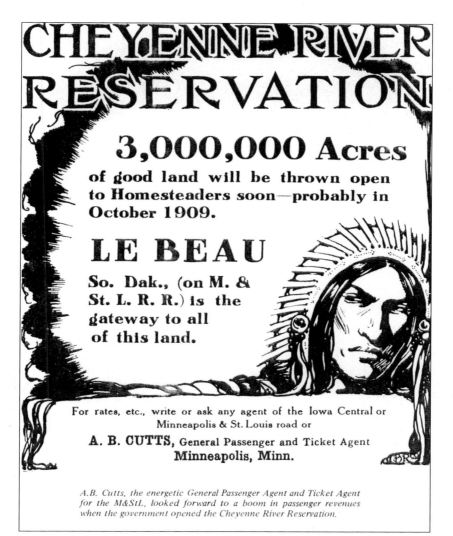

CHEYENNE RIVER RESERVATION POSTER, 1909. This poster advertises 3,000,000 acres of land available for non-Indian farmers under the Homestead Act. This was Lakota land that the government deemed "surplus" land, greatly diminishing the size of the reservation and violating terms of the 1868 Ft. Laramie Treaty. LeBeau, South Dakota was originally Evarts, South Dakota and is now abandoned. (Poster courtesy of Donovin Sprague.)

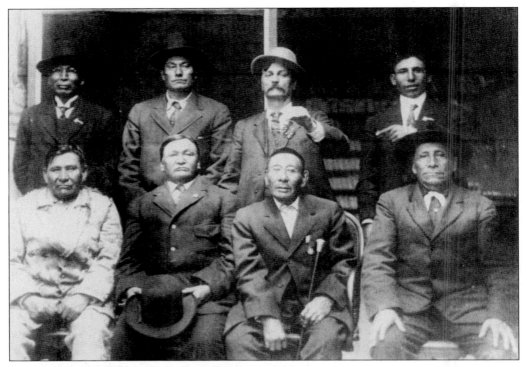

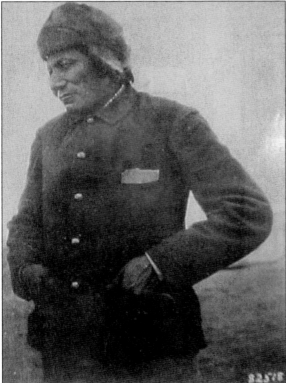

DELEGATION FROM CHEYENNE RIVER AGENCY AT WASHINGTON D.C., MARCH 1910. From left to right are: (standing) James Crow Feather (Itazipco), Justin Black Eagle (Minnicoujou), Fred LaPlant (Minnicoujou/French), Percy Phillips (Oohenumpa); (seated) Patrick Miller (Minnicoujou), Roan Bear (Oohenumpa), No Heart (Minnicoujou), and Runs The Enemy (Oohenumpa). The photo was by DeLancey Gill. (Photograph courtesy of South Dakota State Historical Society.)

HUMP (MINNICOUJOU), TAKEN AT FORT BENNETT IN 1890. At this time Hump was a Chief (Itancan) and also a U.S. Scout in uniform. (Photograph courtesy of the National Park Service, Little Bighorn National Monument.)

WHITE BEAVER, TAKEN BY DeLANCEY GILL IN 1910. He was Dakota/Minnicoujou and was also known as Patrick "Paddy" Miller. He has elaborate porcupine quillwork on his jacket. The quillwork was used for Lakota decoration prior to the arrival of mass produced beads from Europe. The white quills could be dyed natural plant colors and traditional Lakota designs were geometric. This particular jacket reflects the Eastern Dakota style of floral designs. (Photographed courtesy of the Smithsonian Institute.)

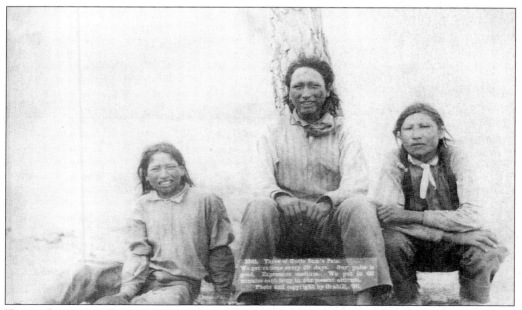

THREE LAKOTAS, PERHAPS BROTHERS, IN AN UNDATED PHOTO. (Photograph courtesy of Donovin Sprague.)

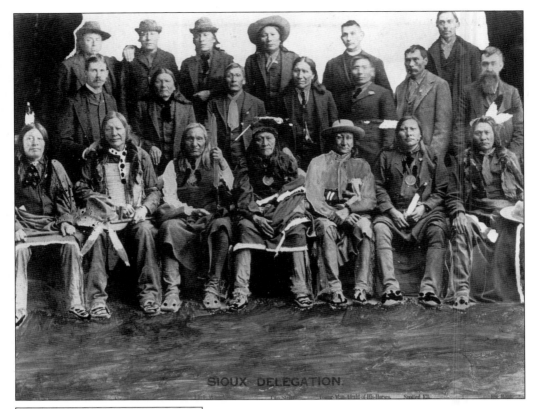

SIOUX DELEGATION.

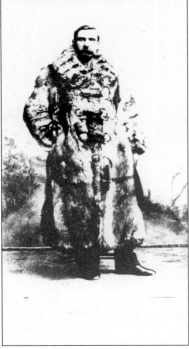

DELEGATION OF INDIANS, WASHINGTON D.C., 1891.
Pictured, from left to right, are: (front row, seated)
High Hawk, Fire Lightning, Little Wound, Two Strike,
Young Man Afraid Of His Horses, Spotted Elk (Oglala),
Big Road; (second row, standing) Dave Zephier, Hump,
High Pipe, Fast Thunder, Rev. Charles Cook, and P.T.
Johnson. This group includes representatives of Lakota,
Dakota, and the Nakota often known as the Sioux.
(Photograph courtesy of the Denver Public Library.)

NARCISSE NARCELLE, IN AN UNDATED PHOTO. This
French trader married into the Lakota and had a large
ranching operation. One of his wives was Cecelia
Benoist "Benway." (Photograph courtesy of Thomas
O'dell Collection, Black Hills State University.)

BASIL/BAZIL CLEMENT (LEFT) AND PAUL NARCELLE, UNDATED. These men were early French traders and ranchers who married into the tribe. The Clement name would become Claymore. The Narcelle name was "Marsil" from Quebec, Canada. (Photograph courtesy of Donovin Sprague.)

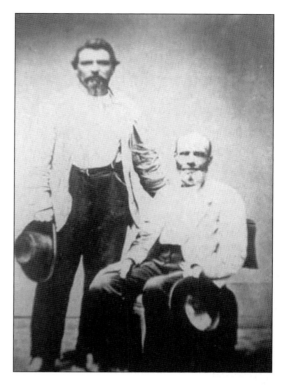

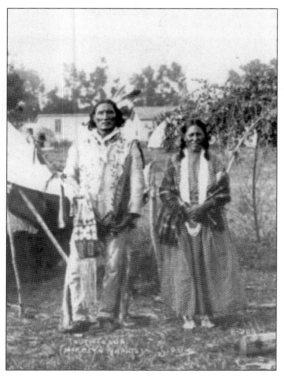

TOUCH THE CLOUD, AND HIS WIFE LIGHT WOMAN (MINNICOUJOU), IN AN 1898 PHOTO BY F.A. RINEHART. (Photograph courtesy of the Omaha Public Library.)

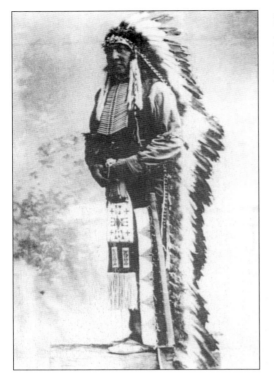

PAUL CROW EAGLE, C. 1909, IN A PHOTO AT CHEYENNE RIVER BY CHRISTENSEN PHOTO, PIERRE, SOUTH DAKOTA. (Photograph courtesy of South Dakota State Historical Society.)

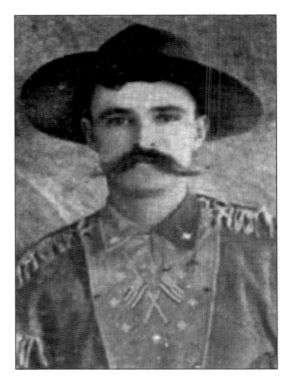

DOUG CARLIN (UNDATED) MARRIED MARCELLA DUPRIS, DAUGHTER OF FRED DUPRIS AND MARY GOOD ELK WOMAN (MINNICOUJOU). He became a South Dakota State Senator. Carlinville, Illinois is named for his relative, who was a territorial governor. (Photograph courtesy of Neil Rousseau and Dee Schumacher.)

RED SKIRT (MINNICOUJOU) AND JOHN SANS ARC, AN ITAZIPCO, 1884. (Photograph courtesy of the Smithsonian Institute.)

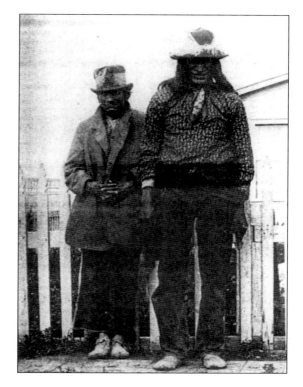

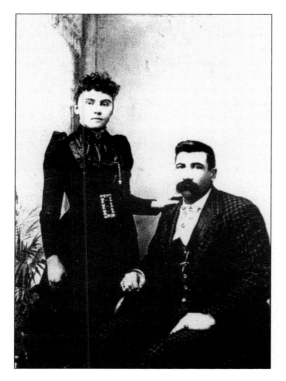

ADELE "IDA" BENOIST (MINNICOUJOU) AND HER HUSBAND EDWARD NARCELLE (FRENCH/LAKOTA), UNDATED. The picture was taken by Kelly Photo. (Photograph courtesy of Theo Rousseau.)

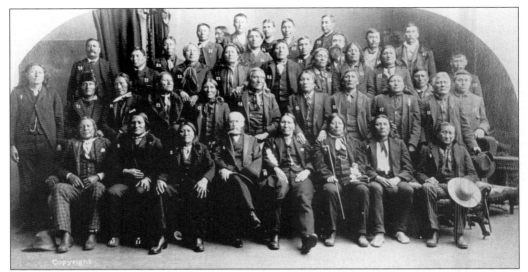

FULL DELEGATION OF SIOUX INDIANS, TAKEN IN WASHINGTON D.C., 1891. This photo taken by C.M. Bell. Pictured from left to right are: (front row) Fire Lightning, John Grass, Two Strike, Commander T. J. Morgan, American Horse, High Hawk, High Pipe, and Young Man Afraid Of His Horses; (second row) Hollow Horn Bear, Crazy Bear, Medicine Bull, White Ghost, Quick Bear, Little Wound, Fast Thunder, Spotted Horse, Spotted Elk (Oglala), Grass, and Dave Zephier; (third row) Louis Richards, Clarence Three Stars, Big Mane, Big Road, Hump, Good Voice, White Bird, He Dog, One To Play With, and Pete Lamont; (fourth row) Wize, No Heart, Mad Bear, Straight Head, F.D. Lewis, Major Sword, Turning Hawk, Robert American Horse, Rev. Luke Walker, Bat Pourieau (Pourier), Alex Recontreau (RenCountre), and Louis Shangrau (Shangreaux). (Photograph courtesy of Donovin Sprague.)

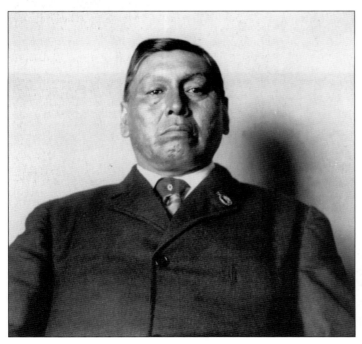

AMOS CHARGING FIRST, TAKEN BY DELANCEY GILL, APRIL 1908. A Minnicoujou, and a son of Touch The Cloud, he lived at Cherry Creek. (Photograph courtesy of Donovin Sprague.)

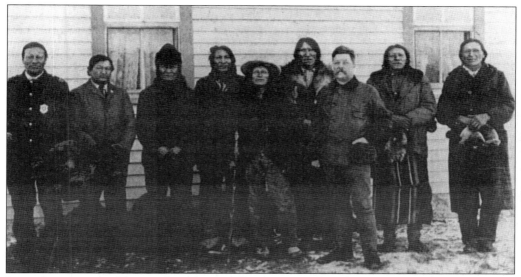

IRON LIGHTNING, HUMP, GOVERNOR HERREID, BLACK EAGLE. Iron Lightning, Hump, Governor Herreid, Black Eagle are pictured from left to right in this undated photo marking the South Dakota Governor's visit to the Cheyenne River. Others are unidentified. (Photograph courtesy of Donovin Sprague.)

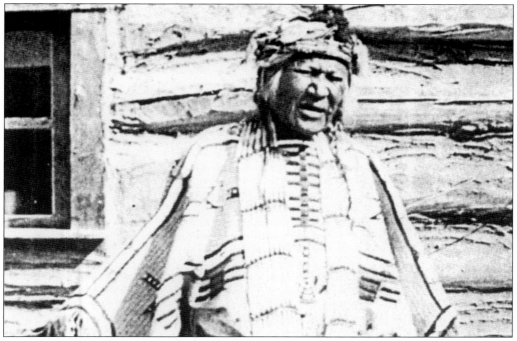

ESTHER SMOKEY (SMOKE) WOMAN, UNDATED. Smoke Woman lived at Cherry Creek and stated that she was a sister of Chief Crazy Horse. The log cabin pictured here still stands. (Photograph courtesy of Donovin Sprague.)

MAKES IT LONG, TAKEN ABOUT 1895. This Minnicoujou was with the Indian Police as a Scout. This name would evolve to Long and family members included High Hawk. His grandchildren would include Clement Long Sr. and Debbie (Long) Day, both from Cheyenne River. (Photograph courtesy of Donovin Sprague.)

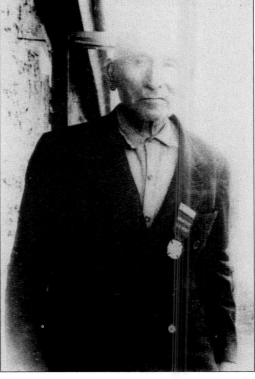

MAKES IT LONG. Makes It Long is pictured here in his later years at his home in Bridger, South Dakota with his U.S. Indian Scout medal. (Photograph courtesy of Donovin Sprague.)

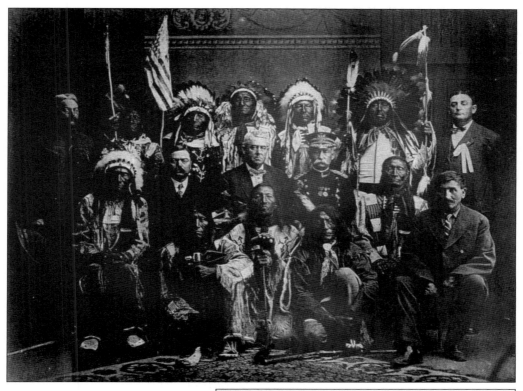

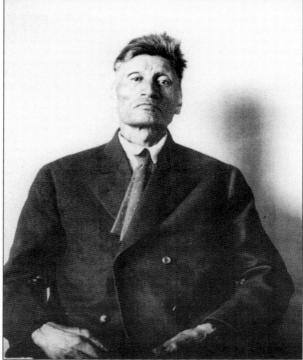

CHEYENNE RIVER INDIAN COUNCIL, TAKEN IN PIERRE, SOUTH DAKOTA 1908. Pictured, from left to right, are: (standing) Major Bentley, Little Shield, Lone Eagle, Iron Lightning, Fish Gut, Charging First, and G.H. Jaynes; (seated) Brown Thunder, C.H. Englesby, Governor Vessey, Colonel Frost, Yellow Owl, and Giles Tapetonwan or Tapeopla (interpreter); (seated or kneeling in front) Afraid Of Enemy (Feared By Enemy), Puts On His Shoes (Swan), and White Bull (Lazy White Bull). (Photograph courtesy of South Dakota State Historical Society.)

JOHN WOODPILE, PHOTO TAKEN BY DELANCEY GILL, 1907. John was a Cheyenne River Lakota who was born in 1850. He was about 57 years old when this picture was taken. (Photograph courtesy South Dakota Historical Society.)

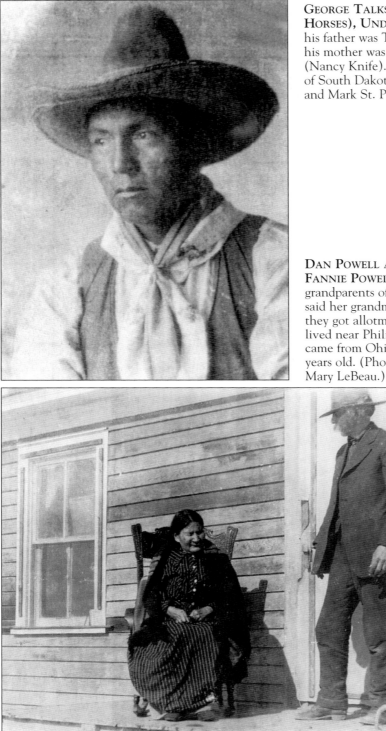

GEORGE TALKS (TAKES THE HORSES), UNDATED. Born in 1878, his father was Talks About Him and his mother was Otter Woman (Nancy Knife). (Photograph courtesy of South Dakota Historical Society and Mark St. Pierre.)

DAN POWELL AND HIS WIFE, FANNIE POWELL. They were grandparents of Mary LeBeau, who said her grandmother was Oglala, but they got allotments on Bad River and lived near Philip, S.D. Dan Powell came from Ohio. Mary is now 94 years old. (Photograph courtesy of Mary LeBeau.)

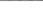

STANDING ELK AND FAMILY (MINNICOUJOU), UNDATED GLASS PLATE. This is likely, back row: son Thomas or Phillip, Matthew Standing Elk; front row: stepdaughter Ellen Talks (About Him), and Matthew's wife Susie White Weasel. (Photograph courtesy of South Dakota State Historical Society.)

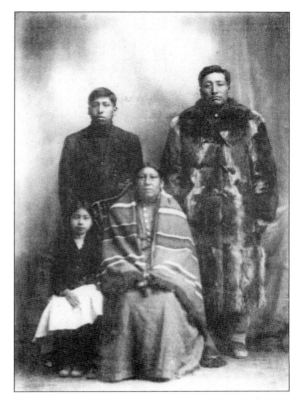

WICINCALAS (YOUNG GIRLS) AT CHEYENNE RIVER C. 1880S. Standing in center are Kate Hunter, Ota Ktewin, and Marcella Dupris (Minnicoujou). By the tent are Maggie and Amy Dupris (Minnicoujou), and in front of the tent is Bessie Flexible. (Photograph courtesy of South Dakota State Historical Society.)

AUGUST (KID) RICH AT CHEYENNE RIVER, FEBRUARY 22, 1903. Mystery and legend surround the unresolved murder of Kid Rich. His body is on display prior to the burial. (Photograph courtesy of Irwin Richardson)

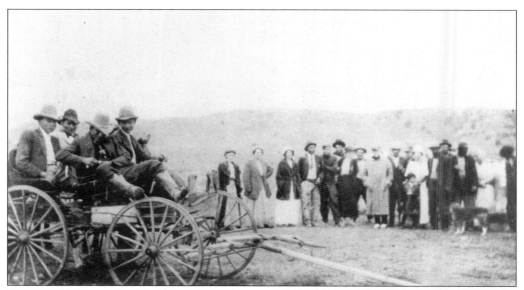

BRIDGER VILLAGE, SOUTH DAKOTA, TAKEN IN 1915. In the wagon, from left to right, are an unidentified man, either Charlie Dog or Nelson In The Hole, Guy Buffalo (showing new yellow boots) and Henry Red Horse. Standing from left to right are Susan Olsen, fifth is George Olsen, sixth is Johnnie Olsen, ninth is Lester Olsen (in the trench coat). This was the Bridger District 90 school picnic. (Photograph courtesy of Grant Olsen.)

FRED DUPRIS JR. (MINNICOUJOU) AND HIS WIFE EMILY EAGLESHIELD, UNDATED. Fred was the son of Fred Dupris and Mary Good Elk Woman. Emily was from the Lower Brule/Crow Creek area. (Photograph courtesy of South Dakota State Historical Society.)

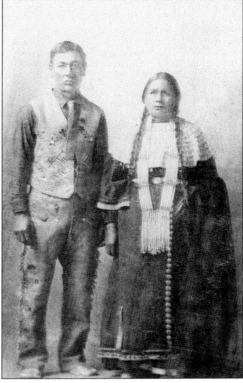

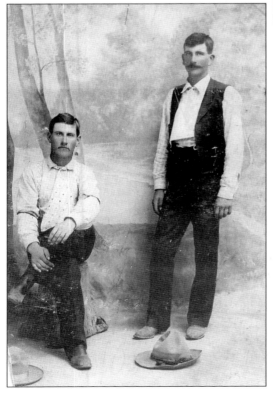

SAM ROUSSEAU AND WALTER MADISON. Sam and Walter were brothers-in-law. Sam was the grandfather of Dee Schumacher and Neil Rousseau, who submitted the photo. It is undated, and is from the R.L. Kelly Studio, Pierre, South Dakota. (Photograph courtesy of Neil Rousseau and Dee Schumacher.)

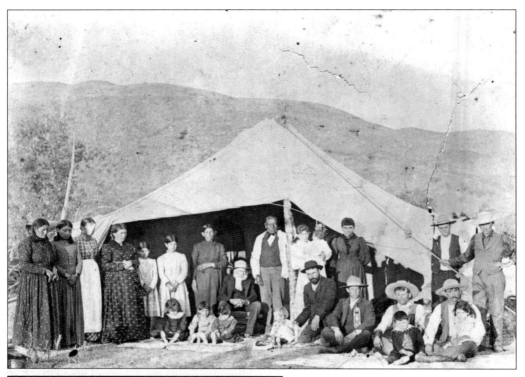

CHEYENNE RIVER GROUP, UNDATED PHOTO. Pictured, from left to right: (back row) the first three women are unidentified, Lucy Pardis, Lucy Rousseau, Julian Narcelle, Grandpa Narcelle, James White Swan, Louise Rich, Narcisse Rich, Ellen Rousseau, Gene Rousseau, and Romuel Rousseau; (front row) unidentified, Agnes Pardis, Susie Lecompte, Albert Pardis, unidentified baby, George Pardis, Oscar Rousseau, Amadee Rousseau, boy is Francis Rousseau, Paul Rousseau, and Louise Rousseau. (Photograph courtesy of Junior Rousseau Collection.)

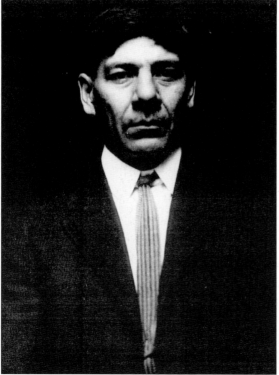

FRANK DUPRIS (MINNICOUJOU), TAKEN BY DELANCEY GILL, MAY 1914. He was called Atayela Kte and was the son of Fred Dupris and Mary Good Elk Woman (Photograph courtesy of Donovin Sprague.)

SAM HERROLD AND WIFE MARCELLA DUPRIS (MINNICOUJOU), UNDATED. This is Marcella's second marriage following the death of her first husband, Doug Carlin. (Photograph courtesy of Neil Rousseau and Dee Schumacher.)

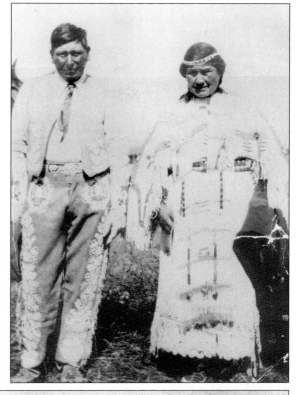

JOSEPH/PETER CLOWN AND WIFE, EMELINE DID NOT GO HOME, UNDATED. Joseph Clown was born in 1894 and lived until 1963. Emeline, born in 1900, lived until 1978. They had eight children, one of whom, Elsie Clown Slides Off, provided this photo. The parents of Joseph were Amos and Julia (Iron Cedar) Clown. (Photograph courtesy of Elsie Slides Off.)

JOE CLAYMORE, PHOTO UNDATED.
Joe was a brother of Odette Claymore
Voss's grandfather and was married
seven times. (Photograph courtesy of
Odette Claymore Voss.)

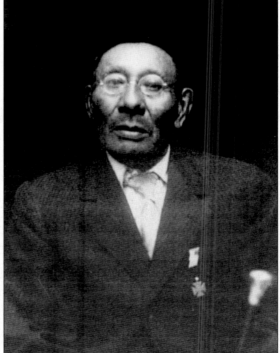

**NO HEART (MINNICOUJOU), TAKEN BY
DeLANCEY GILL, MARCH 1910.** No
Heart was the grandfather of Gus
Kingman. (Photograph courtesy of
Smithsonian Institute.)

Marcella Dupris Carlin (left) and Daughter Grace Rousseau, Undated. Marcella later married Sam Herrold, a minister, in 1921, after her first husband Doug Carlin passed away. Grace Carlin married Romie Rousseau. Marcella was from the Minnicoujou family of Fred and Mary Dupris. (Photograph courtesy of Neil Rousseau and Dee Schumacher.)

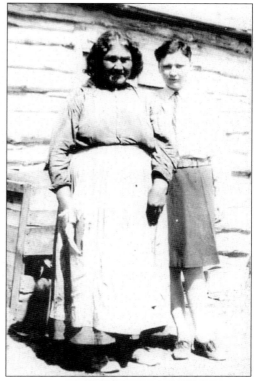

Cheyenne River Delegation to Washington D.C. This photo was taken by DeLancey Gill on April 7, 1908. Pictured from left to right are: (standing) Robert F. Higheagle, Amos Charging First, Allen Fielder, Edward Dupris, James White Plume, Paul Crow Eagle, Antoine DeRockbrain, Joseph Claymore, and Thomas Frosted; (seated) Percy Phillips, Charles W. Rastall (agent), Fred LaPlant, and Stephen Blackbody. (Photograph courtesy Smithsonian Institute.)

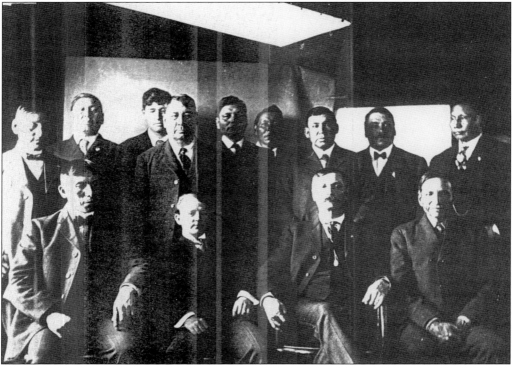

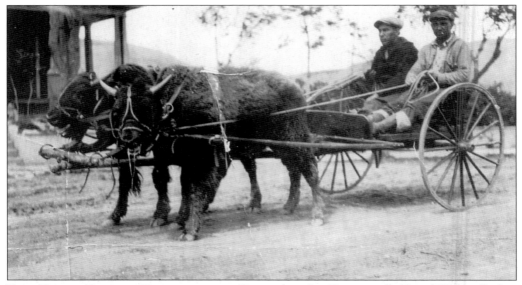

FRED DUPREE BUFFALO TEAM, UNDATED. Pictured are Jess Rousseau (left) and Walter Carlin. They are uncles of Neil Rousseau and Dee Schumacher, who submitted the photo. (Photograph courtesy of Neil Rousseau and Dee Schumacher.)

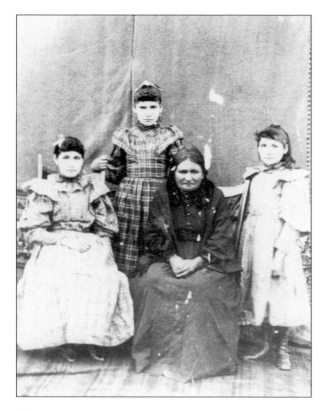

VOSS FAMILY PHOTO, UNDATED. Pictured from left to right are Alphonsine (Garreau) Merrit, Caroline (Garreau) Maupin, Cedar Woman aka Mary Powder River, and Esther (Garreau) Shepard. The girls are the aunts of Odette (Claymore) Voss' mother. The grandmother is Cedar Woman. (Photograph courtesy of Odette (Claymore) Voss.)

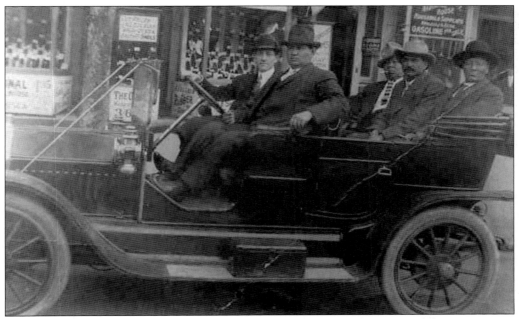

WASHINGTON DELEGATION, EARLY 1900S. Bazil Claymore is in the center of the rear car seat. They were protesting the opening of homesteads. (Photograph courtesy of Junior Rousseau Collection.)

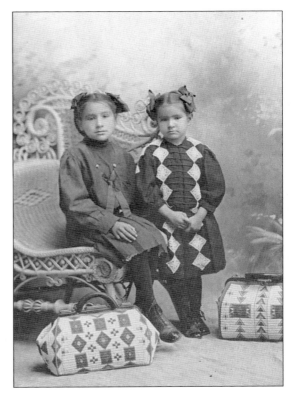

JOSEPHINE CLAYMORE (LEFT) AND HER SISTER ELIZABETH CLAYMORE, TAKEN c. 1911. Josephine was born in 1902 and was about nine years old at the time of this picture. Elizabeth was about seven. The beaded suitcases were made by Mrs. Paddy Miller. Odette Voss showed me one of the suitcases. (Photograph courtesy of Odette Claymore Voss.)

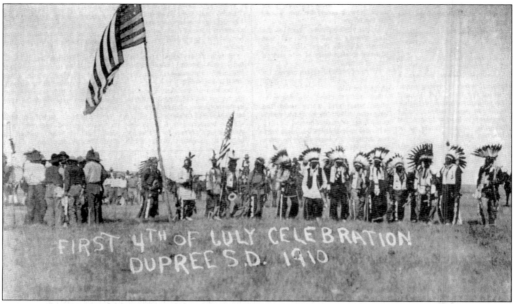

DUPREE, SOUTH DAKOTA, 1910. This is the town's first Fourth of July celebration. The town was named for the Dupris/Dupree family and is the county seat of Ziebach County. (Photograph courtesy of Pauline Meister.)

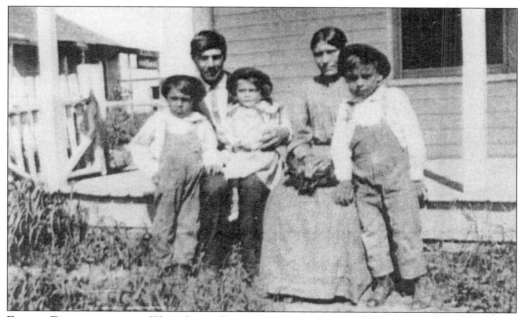

FRANK DUPRIS AND HIS WIFE SARA REDHORSE DUPRIS AND CHILDREN IN AN UNDATED PHOTO. The children pictured from left to right are Sam Dupris, Ben Dupris, and Jonas Dupris. Jonas was the father of Cal Dupree. The family is Minnicoujou and uses different spellings for their last name. Frank Dupris was born in 1878 and was the son of David Xavier Dupris and Harriet Cadotte Dupris. (In this picture one child may be a girl as they had two daughters, Josephine and Lula.) (Photograph courtesy of South Dakota Historical Society.)

HARRIET (CADOTTE) AND DAVID XAVIER DUPRIS IN AN UNDATED PHOTO. David Dupris (Minnicoujou) was the son of Fred Dupris and Mary Good Elk Woman. Many of the Cadottes are Hunkpapa. Pictured here are four of their five children; Frank (the oldest), Louise (second child), Joseph (third), William (fourth), and Bessie (fifth). (Photograph courtesy of South Dakota State Historical Society.)

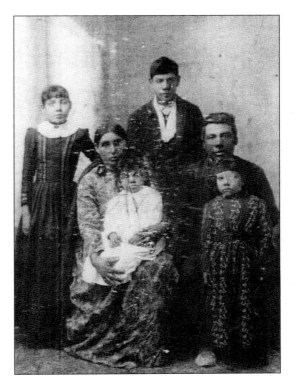

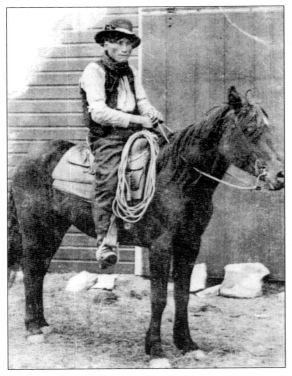

HENRY BLACKSMITH, UNDATED. A Cheyenne River Lakota, Henry was born in 1887. His father was Blacksmith and his mother was named Rattling. Henry had four brothers; John, Joseph, Thomas, and Luke. (Photograph courtesy of South Dakota State Historical Society and Mark St. Pierre.)

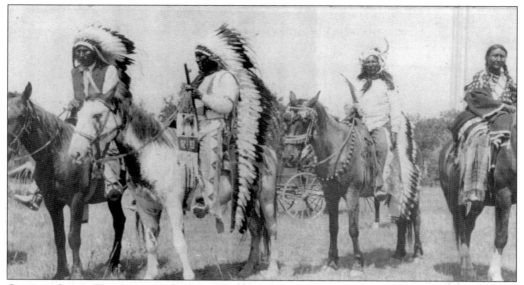

CHERRY CREEK FOURTH OF JULY CELEBRATION, 1918. Pictured from left to right are Jack Bull Eagle, Amos Charging First, Fish Gut, and Mrs. Charley Red Horse. (Photograph courtesy of Virginia Spurling and Faye Longbrake.)

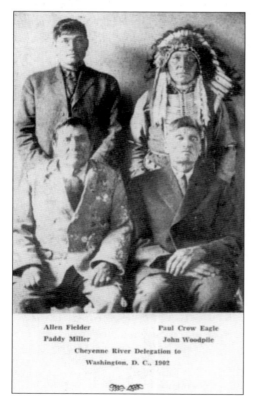

CHEYENNE RIVER DELEGATION, C. 1902. Pictured from left to right: (front row) Paddy Miller and John Woodpile; (back row) Allen Fielder and Paul Crow Eagle. (Photograph courtesy of Donovin Sprague.)

ALFRED WARD (MINNICOUJOU), TAKEN NEAR HUMP FLAT. Alfred was born in 1877 and married Hump's daughter, Nellie Hump, who was born in 1882. His parents were Roan Bear-Clarence Ward and Estella Dupris Ward. (Photograph courtesy of Irwin Richardson.)

NELLIE HUMP IN AN UNDATED PHOTO.

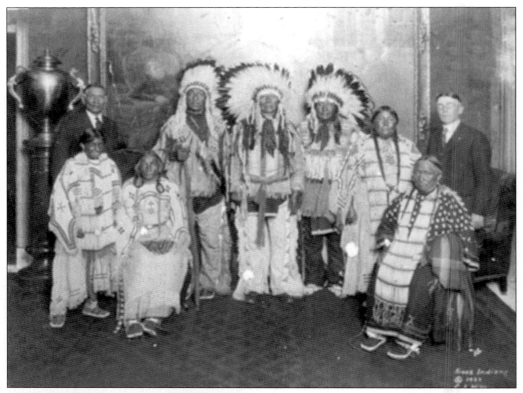

CHEYENNE RIVER INDIAN DELEGATION PHOTO TAKEN AT WASHINGTON D.C., 1923. Pictured from left to right are: (front row) daughter of Straight Head, and Mrs. Straight Head (seated); (back row) Eastman, Straight Head, Fish Guts, Charger, Mrs. Charger, Major Craig, and Mrs. Fish Gut. (Photograph by C.J. Hibbard and courtesy of South Dakota State Historical Society.)

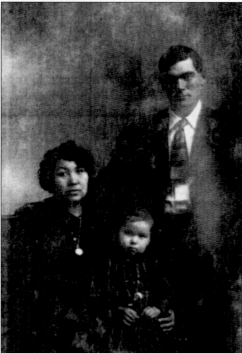

FLOYD ANNIS FAMILY WITH WIFE MARY/MOLLIE DUPRIS AND THEIR DAUGHTER JENNIE, UNDATED. Mary/Mollie was born in 1889 and was the daughter of Fred Dupris Jr. and Emily Eagle Shield. The children of Floyd and Mollie were Marguerite, Eugenia (Burgee), David Annis, Delbert Annis, and Jennie (Hunt). A daughter, Geniveve Elizabeth, died in infancy. Molly was known as Nape Waste Win (Good Hands Woman). (Photograph courtesy of South Dakota State Historical Society.)

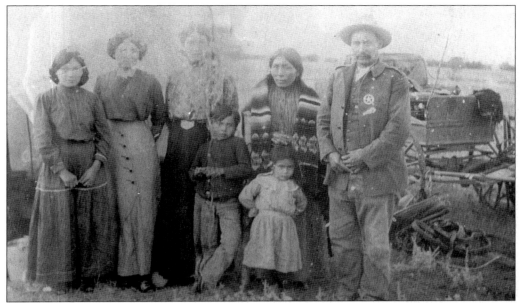

LYMAN FAMILY, TAKEN AT DUPREE, SOUTH DAKOTA. Pictured from left to right are: (back row) Esther Lyman, Violet Williams, Clara Lyman, Agnes Lyman, and Edward Lyman; (front row) Joe Lyman and Bertha Lyman (children). Bertha Lyman married John Hump. (Photograph courtesy of Irwin Richardson.)

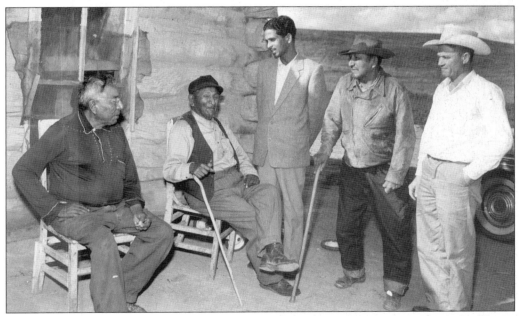

LEO LITTLE CROW (MINNICOUJOU), BOB FIRST EAGLE, ROMA RAUJ, PAUL CHASING HAWK (MINNICOUJOU), AND IRWIN RICHARDSON. This photo, taken at Hump Flat, is undated. Irwin Richardson brought an exchange student from India, Roma Rauj, to visit these Lakotas. Little Crow was a brother of Hump. Irwin Richardson ranched on the reservation. Now retired, he has reached the age of 94. (Photograph courtesy of Irwin Richardson.)

SIMON WALKING HUNTER AT CHEYENNE RIVER, C. 1941. Simon lived on the south end of Cheyenne River Reservation. He was a neighbor to Pauline Meister who lives in Rapid City, South Dakota. (Photograph courtesy of Donovin Sprague.)

MARY TRAVERSIE DUPRIS TALKS AND AMY TALKS, UNDATED. Mary is on the far right with daughter Amy in front of her; the others are unidentified. Mary Traversie was born in 1870 and attended Hampton Institute in Virginia. She was married to Edward Dupris in 1890 and later to Peter Talks. Her daughter, Amy Talks, was born in 1913 and married Edward Clown, who was born in 1908. Edward Clown was the son of Amos and Julia (Iron Cedar) Clown. (Photograph courtesy of Ziebach County History book.)

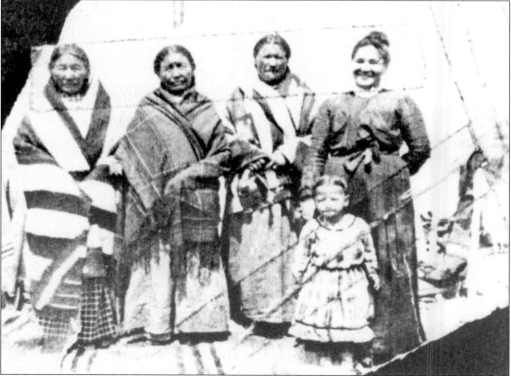

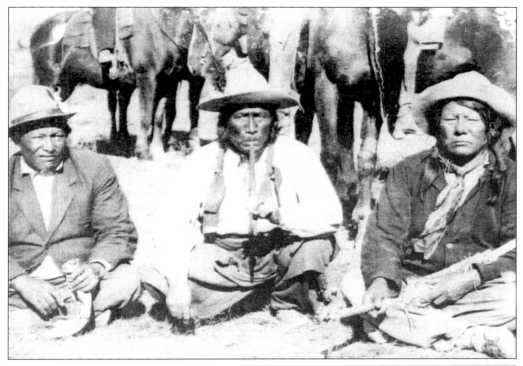

WHITE HAND BEAR, WHITE HAWK AND POOR ELK, TAKEN AT DUPREE, SOUTH DAKOTA, UNDATED PHOTO BY CUNDILL. (Photograph courtesy of South Dakota State Historical Society/Mark St. Pierre.)

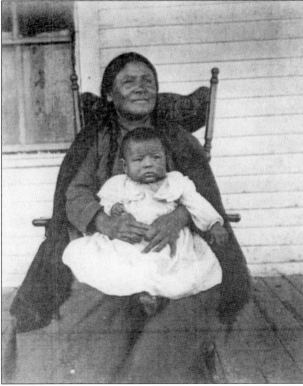

MRS. WHITE DOG AND BABY, UNDATED AT CHEYENNE RIVER. (Photograph courtesy of South Dakota State Historical Society.)

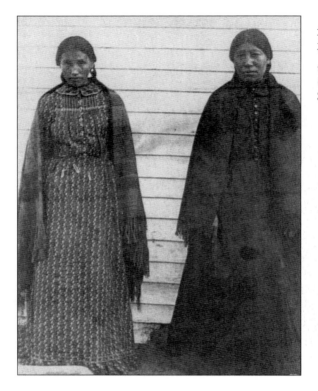

AMY SWAN (MINNICOUJOU), ON THE RIGHT, AND AN UNIDENTIFIED WICINCALA. This is an undated photo taken at Cheyenne River. (Photograph courtesy of South Dakota State Historical Society.)

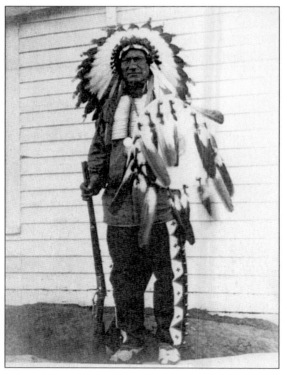

UNIDENTIFIED WICASA, UNDATED AT CHEYENNE RIVER. He wears traditional dress and holds a rifle. (Photograph courtesy of South Dakota State Historical Society.)

ISAAC ARPAN AND UNIDENTIFIED. Isaac Arpan, the rider on the left, and an unidentified man are featured in this undated photo at Cheyenne River. (Photograph courtesy of South Dakota State Historical Society.)

GARREAU FAMILY, TAKEN C. 1904. Pictured from left to right are Seraphine, Alex, William, Gilbert, Caroline, and Jennie holding Charlie Garreau. William's parents were Solomon Garreau and Mary Powder River. Jennie On The Lead's parents were Two Shields and Mary Yellow Hair Swan. Alex was born in 1906. (Photograph courtesy of Monica Garreau Schmidt.)

CAMP ON ROUSSEAU CREEK, 1902. This is where St. Peter's Catholic Church was located along with tents and tipis of the camp in the background. The building on the left had 14 rooms. (Photograph courtesy of Junior Rousseau Collection.)

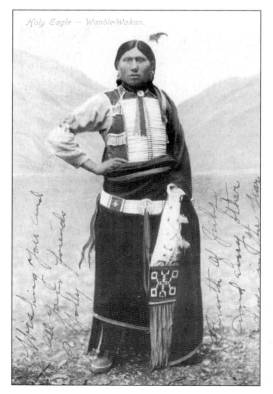

Holy Eagle — Wanble-Wakan.

JAMES HOLY EAGLE? (OGLALA) POSTCARD FROM 1907. This postcard came to the Holy Eagle family (Minnicoujou/Oglala) and family members think this could be their relative James Holy Eagle (Wambi Wakan). (Postcard courtesy of Sonja Holy Eagle Family, Catherine Brings The Horses Silva and Family, D.M. Lunday, and Donald Barnhart.)

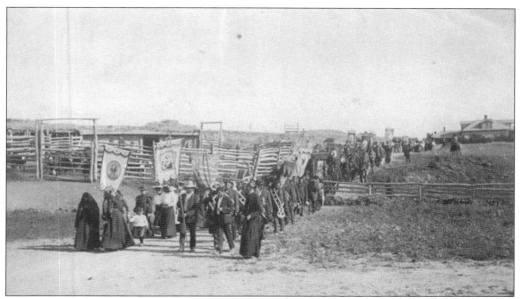

CATHOLIC CHURCH DEDICATION, TAKEN AT ROUSSEAU CREEK C. 1902. This area was about 16 miles south of Ridgeview, South Dakota. (Photograph courtesy of Junior Rousseau Collection.)

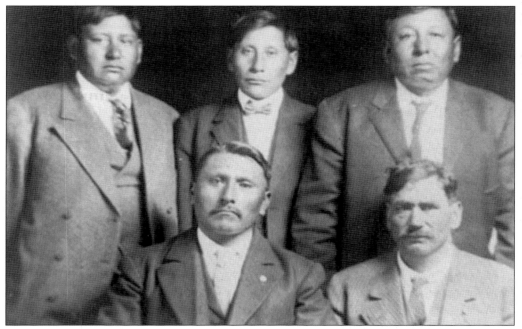

WASHINGTON D.C. DELEGATION, TAKEN IN 1912. Pictured from left to right are: (front row) Straight Head and Bazil Claymore, Jr.; (back row) Jim Swan, Black Eagle, and Ed Swan. (Photograph courtesy of Junior Rousseau Collection.)

SAM CHARGER, (LEFT) (ITAZIPCO) AND LUKE GILBERT (MINNICOUJOU) IN AN UNDATED PHOTO TAKEN BY LAPPOL STUDIO, WASHINGTON D.C. Luke Gilbert was first elected Cheyenne River tribal chairman in 1936 and served until 1942. Sam Charger succeeded him and served from 1942 until 1946. (Photograph courtesy of Donovin Sprague.)

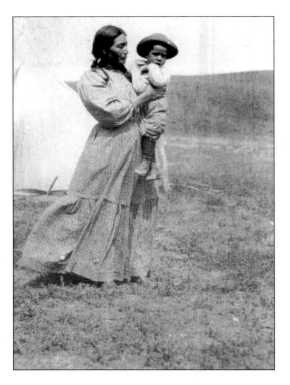

JENNIE (WALKS FIRST WOMAN) GARREAU, HOLDING SYLVESTER GARREAU, TAKEN C. 1914. Jennie's Indian name was Tokeyamniiwin (Walks First Woman). Her married name was Jennie White Swan. She is Minnicoujou/Itazipco. (Photograph courtesy of Monica Garreau Schmidt.)

ROSE WHITE EYES GARREAU, UNDATED.
Rose was the grandmother of Monica
Garreau Schmidt, who provided this photo.
Monica's family is a mixture of
Minnicoujou, Itazipco, and French.
(Photograph courtesy of Monica Garreau
Schmidt.)

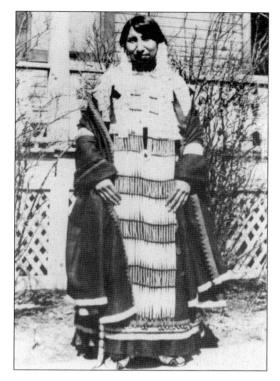

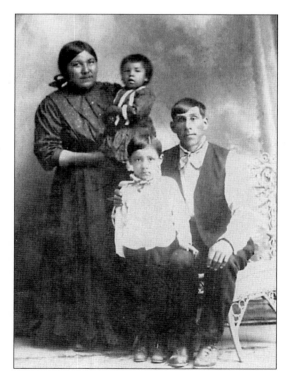

**LOUIS JR., AND ELIZABETH GARREAU
(ITAZIPCO) WITH THEIR CHILDREN JOSIE
AND MILTON GARREAU IN AN UNDATED
PHOTO.** Louis and Elizabeth were the
parents of sisters Ruby Marshall and Edith
Traversie. (Photograph courtesy of Ruby
Marshall and Edith Traversie.)

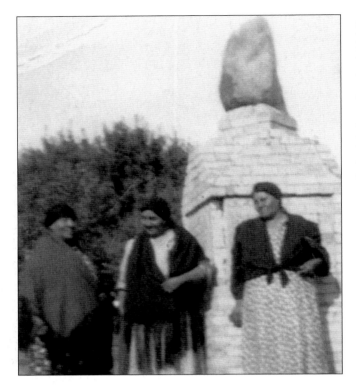

STANDING ROCK VISIT.
Pictured from left to right are Ruth Thunder Hoop, Elizabeth (Yellow Hawk) Meeter, and Bessie (Yellow Hawk) Veo in an undated photo. Elizabeth is the mother of Ruby Marshall and Edith Traversie. These women are visiting Standing Rock. (Photograph courtesy of Ruby Marshall and Edith Traversie.)

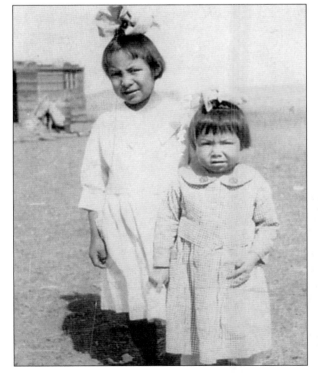

RUBY GARREAU MARSHALL (LEFT) AND EDITH GARREAU TRAVERSIE (ITAZIPCO), UNDATED. The sisters are ready for church. (Photograph courtesy of Ruby Marshall and Edith Traversie.)

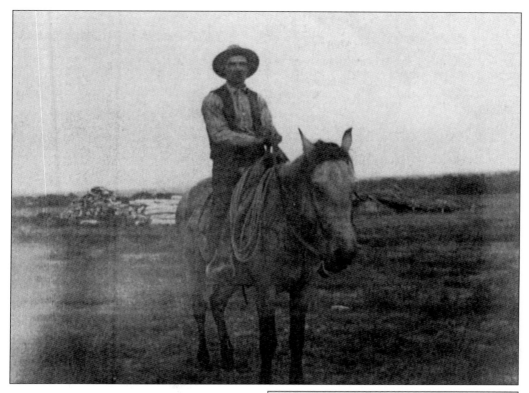

CHARLIE LAPLANT, UNDATED, AT CHEYENNE RIVER. He lived south of Faith, South Dakota. (Photograph courtesy of South Dakota State Historical Society.)

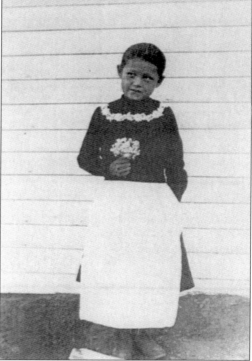

IRENE TRAVERSIE LIND, UNDATED, AT CHEYENNE RIVER. (Photograph courtesy of South Dakota State Historical Society.)

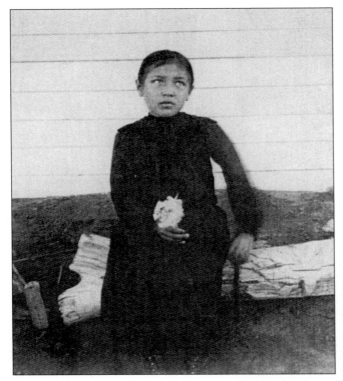

CHRISTINE TRAVERSIE LIVERMONT, UNDATED, AT CHEYENNE RIVER. (Photograph courtesy of South Dakota State Historical Society.)

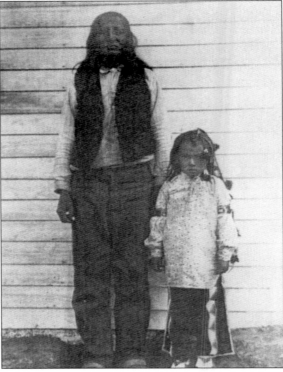

WALTER SWAN AND UNIDENTIFIED, UNDATED, AT CHEYENNE RIVER. "Walter Swan" is written across the front but does not specify. (Photograph courtesy of South Dakota State Historical Society.)

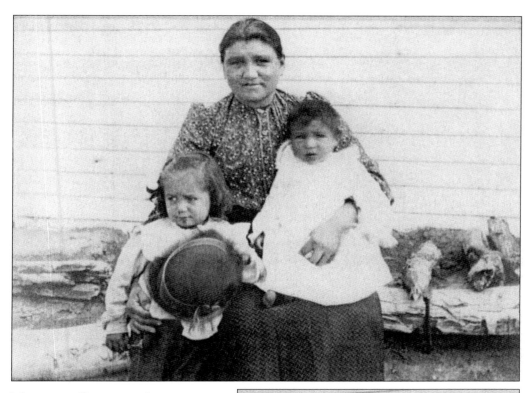

MARGARET CLAYMORE ARPAN, HOLDING DAUGHTERS (LEFT) FLORENCE ARPAN AND MAUDE ARPAN. Margaret's husband was Isaac Arpan. (Photograph courtesy of South Dakota State Historical Society.)

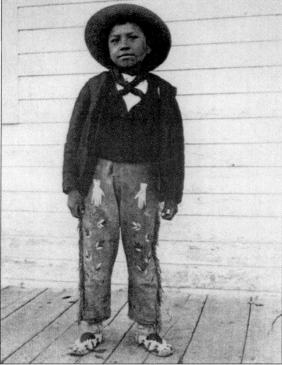

AN UNIDENTIFIED BOY AT CHEYENNE RIVER. (Photograph courtesy of South Dakota State Historical Society.)

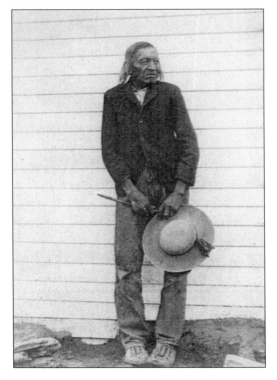

STANLEY LITTLE PRAIRIE CHICKEN AKA TALL PRAIRIE CHICKEN IN AN UNDATED PHOTO AT CHEYENNE RIVER. (Photograph courtesy of South Dakota State Historical Society.)

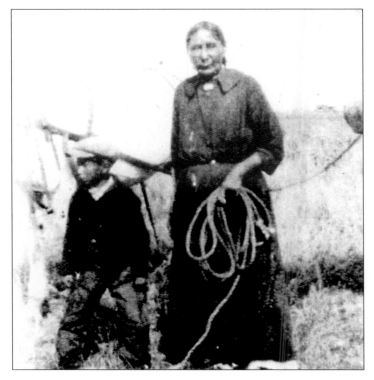

JOE LAUNDREAUX AND HIS MOTHER ALICE GARTER LAUNDREAUX (LAKOTA), PHOTO UNDATED. (Photograph courtesy of Joe Landreaux and Ruby Marshall.)

PHOTO TAKEN AT STATE SOLDIERS HOME, HOT SPRINGS, SOUTH DAKOTA, 1936. Pictured on the left are Bazil Claymore and his wife Mary Martha Hodgkiss. On the right are Isaac Bettleyoun and Susie Bordeaux. Bazil and Mary Martha were Junior Rousseau's great grandparents. Susie Bordeaux was a well-known author. (Photograph courtesy of Junior Rousseau Collection.)

JAMES H. SWAN (MINNICOUJOU), PHOTO UNDATED. His parents were Paul White Swan and Nation Woman also known as Mary Nation. (Photograph courtesy of Shirley Swan Keith and Jodee Brewer.)

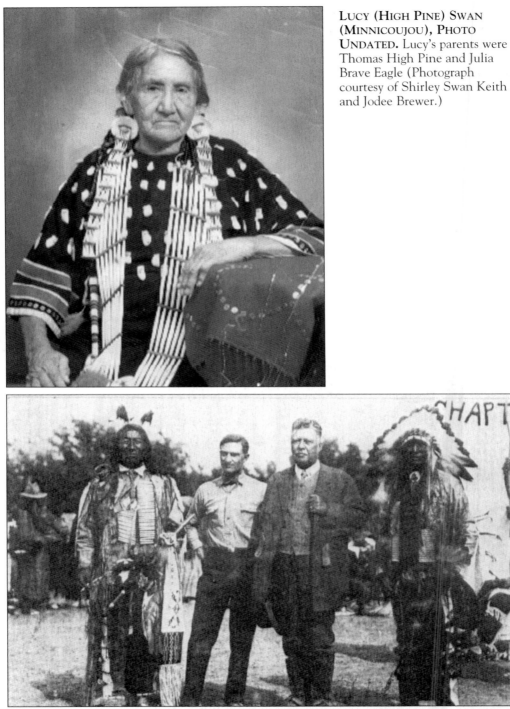

LUCY (HIGH PINE) SWAN (MINNICOUJOU), PHOTO UNDATED. Lucy's parents were Thomas High Pine and Julia Brave Eagle (Photograph courtesy of Shirley Swan Keith and Jodee Brewer.)

TWO CHEYENNE RIVER LAKOTAS WITH PROFESSOR DUNN AND GOVERNOR HERREID IN A PHOTO TAKEN AT CHEYENNE RIVER AGENCY, OCTOBER, 1927. (Postcard courtesy of Donovin Sprague.)

ELMER SCOTT AND HIS SISTER BERTHA (SCOTT) ANNIS, UNDATED. Their parents were Charlie Scott and Sophia Gets Off. Bertha married Fat Annis. (Photograph courtesy of Ruby Marshall and Edith Traversie.)

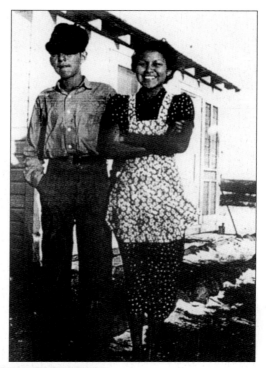

MARY TALKS AND GRANDSON BLAINE CLOWN (MINNICOUJOU) UNDATED. (Photograph courtesy of Ziebach County History.)

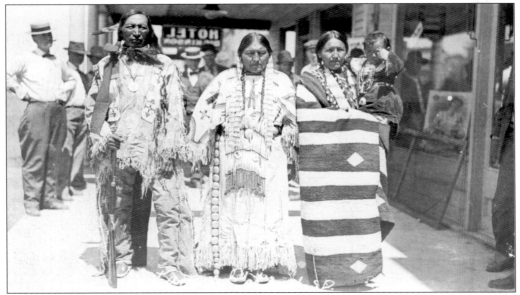

PUTS ON HIS SHOES (WILLIAM SWAN) AND HIS WIFE LUCY (KNIFE) SWAN AND LUCY'S SISTER. This undated photo was taken in Faith, South Dakota. They are a Minnicoujou family. (Postcard courtesy of Donovin Sprague.)

WHITE BULL, NEPHEW OF SITTING BULL, TAKEN AT DUPREE, SOUTH DAKOTA, 1938. (Photograph courtesy of the Denver Public Library.)

JOHN AND IDA CROW, C. 1941, 50TH
ANNIVERSARY OF THE CHEYENNE RIVER
AGENCY PROGRAM COVER. (Photograph
courtesy of Terry Mayes.)

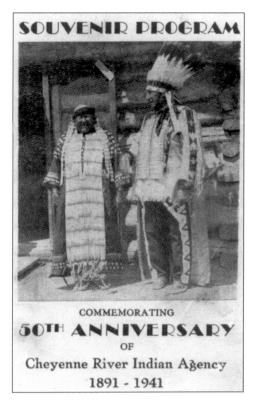

SOUVENIR PROGRAM

COMMEMORATING

50TH ANNIVERSARY

OF

Cheyenne River Indian Agency

1891 - 1941

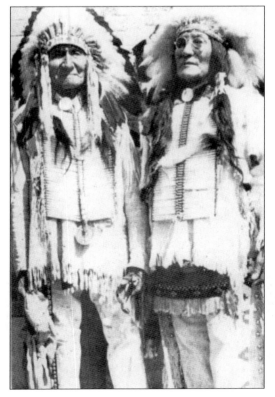

EDWARD ROAN BEAR AND JUSTIN EAGLE
FEATHER, TAKEN AT CHEYENNE RIVER,
1941. This is the 50th Anniversary
celebration of Cheyenne River Sioux
Reservation. Dances were held daily. Justin
was the uncle of Edith Traversie and Ruby
Marshall. (Photograph courtesy of Donovin
Sprague.)

RENA WARD AND ELLEN WARD BENOIST (MINNICOUJOU). Rena was the daughter of John Little Cloud and Ellen was the daughter of Alfred Ward and Nellie Hump (Pretty Voice). Rena is Ellen's sister in law. Photo undated. (Photograph courtesy of Mildred Benway.)

JAMES "DEAFY" EAGLE CHASING (MINNICOUJOU). Born in 1885 or 1886, he lived until 1981. His father was Ray Eagle Chasing and his mother was White Weasel. (Photograph courtesy of South Dakota Historical Society and Ann Fleming.)

DAVE BALD EAGLE (MINNICOUJOU). Dave lives near Cherry Creek with his wife Josie. This undated photo was taken when he was a young man. (Photograph courtesy of Junior Rousseau Collection.)

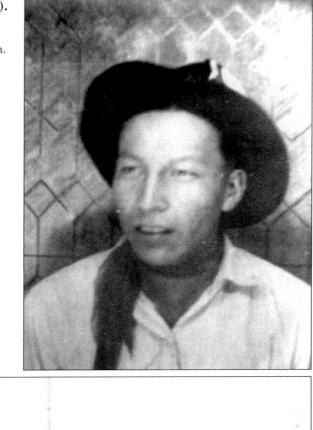

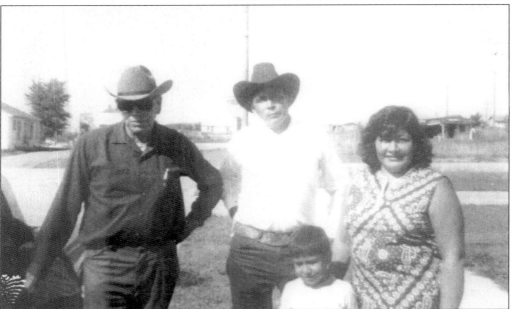

BENWAY AND LONG PHOTO. Pictured from left to right are Doug Benway, Clement Long, Sr., Clement "Dirk" Long, Jr., and Mildred Benway. This photo was taken in Cherry Creek, South Dakota. The name Benway evolved from Benoit and Benoist. Long was shortened from Makes it Long. (Photograph courtesy of Mildred Benway.)

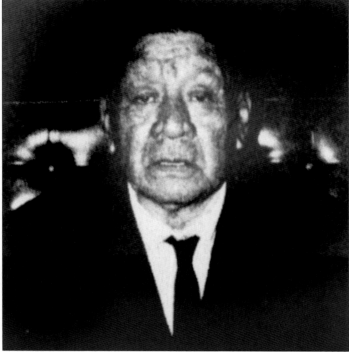

JONAH LITTLE WOUNDED, UNDATED. Jonah was the son of James Little Wounded who was born in 1871 and Delia Center of the Camp who was born in 1869 at Bear Creek. (Photograph courtesy of Ziebach County History book.)

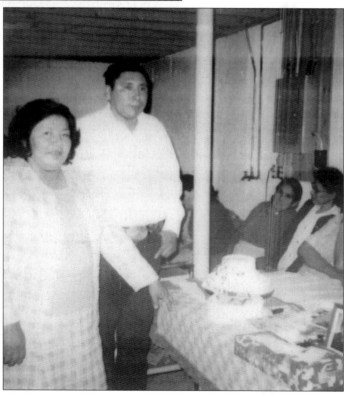

MINNICOUJOU MEMBERS. Pictured from left to right are Mildred Benway Long, Clement Long, Lucy Swan and Madonna (Swan) Abdallah at a 10th wedding anniversary in Cherry Creek. All are Minnicoujou members. The photo was taken in 1976. (Photograph courtesy of Mildred Benway.)

SIDNEY (USES THE KNIFE) KEITH AND HIS WIFE SHIRLEY (SWAN) KEITH (MINNICOUJOU), UNDATED. Sidney's parents were William Uses The Knife and Elizabeth Eagle Chasing. Shirley's parents were James H. Swan and Lucy (High Pine) Swan. Sidney and Shirley are known for preserving Lakota culture. Sidney was an artist and Instructor for Oglala Lakota College in Rapid City and he designed the flag of the Cheyenne River Sioux Tribe.

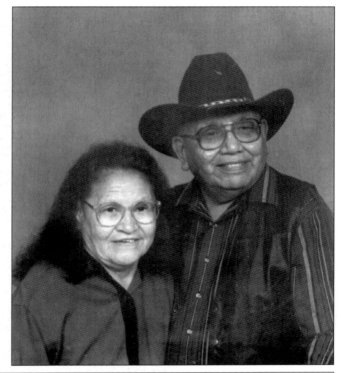

LIFE-LONG FRIENDS, UNDATED. Pictured from left to right are Ruby Marshall, Alice Ducheneau, and Edith Traversie, three life-long friends. (Photograph courtesy of Ruby Marshall and Edith Traversie.)

GUS KINGMAN (MINNICOUJOU) AND GREGG BOURLAND, 2001. Gus was the oldest living Cheyenne River Sioux tribal member at the age of 104. He passed awas on September 25, 2002. He was born on July 6, 1898. Gregg Bourland was chairman of the Cheyenne River Sioux tribe for three terms until 2002. The tribe honored Gus on this day when he was 102 years old. (Photograph courtesy of Gay Kingman and Gregg Bourland.)

GROVER SCOTT (HOWOJU), TAKEN AT LAPLANT, SOUTH DAKOTA, SUMMER 2002. Grover's parents were Charlie Scott and Sophia Gets Off. Sophia comes from the Lone Horn family. Grover is 94 years old and prefers the original spelling of Howoju (later Minnicoujou). (Photograph taken by Donovin Sprague.)

MADELINE LOW DOG HANDBOY (OGLALA), UNDATED. Madeline ("Maggie") was a nurse. She was the granddaughter of Chief Low Dog (Oglala) and her father was Tom Low Dog, son of the Chief. Maggie married Raymond Handboy (Minnicoujou). Maggie and Raymond lived until 1991-92. (Photograph courtesy of Handboy family and Clarissa Gusman.)

PETER HELPER (MINNICOUJOU) AND DAUGHTER DARLENE. This photo was taken at Pine Ridge Indian Reservation in 2002. Pete is 94 years old. His grandfather was Hump. (Photograph courtesy of Donovin Sprague.)

JAMES HOLY EAGLE (OGLALA) AND GRANDDAUGHTER SONJA HOLY EAGLE (MINNECOUJOU/OGLALA). This photo was taken in Rapid City, South Dakota around 1989. James was born in the spring of 1889 and lived to the age of 102; he passed away in 1991. He has family ties to Cheyenne River and attended treaty council meetings at Green Grass. He crossed paths with Jim Thorpe while attending Carlisle Indian School in Pennsylvania and with Irving Berlin when they served in the U.S. Army. James was a musician and played the coronet. His granddaughter Sonja is an artisan and has a business with her husband called Dakota Drums in Rapid City. The author, Donovin Sprague, presented a Proclamation to James Holy Eagle on his 100th birthday while Donovin was chairman of the Rapid City Indian White Relations. (Photograph courtesy of Sonja Holy Eagle family and Catherine Brings The Horses Silva and family.)

MARY (POWELL) LEBEAU AND SON LEWIS LEBEAU (MINNICOUJOU). This photo was taken during the summer of 2002. They were visiting the author on this day and showed the beaded heirloom from their family. Mary is 94 years old. Her parents were Dan Powel Jr., and Mary (Oakes) Powell who was from Greenwood, S.D. (Photograph courtesy of Donovin Sprague.)

Six

Owayawa El' Tipi

(Boarding Schools)

Wounspe Teca

(New Education)

Our tribal members attended early boarding schools. Hampton Institute in Virginia was founded in 1868 as a boarding school for African Americans. Richard Henry Pratt founded Carlisle Indian School in Pennsylvania on the model developed at Hampton, but exclusively for American Indians. The process of assimilation was used to attempt to re-shape American Indians into white society.

By September 1879, Pratt headed into Dakota Territory to recruit Lakota students into Carlisle. Later many boarding schools would begin across the United States.

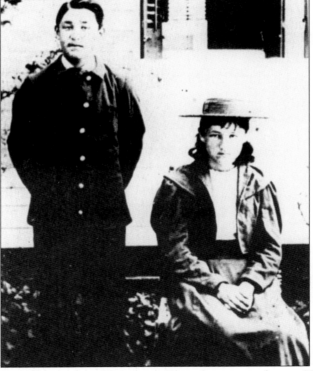

Theo and Elizabeth Traversie, Undated. This photo was taken at Hampton Institute, Virginia. Both students were attending Hampton which was the first Indian boarding school. (Photograph courtesy South Dakota State Historical Society.)

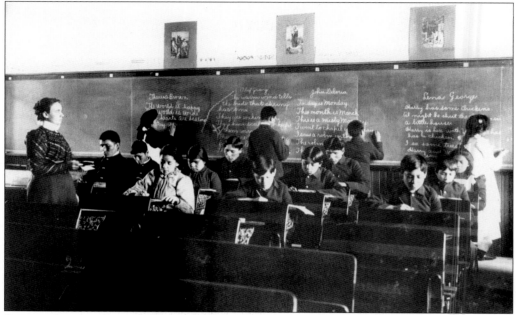

CARLISE INDIAN SCHOOL PHOTO TAKEN AT CARLISE, PA IN 1902. Shown here are members of the first and second grade class. (Photograph courtesy of Cumberland County Historical Society.)

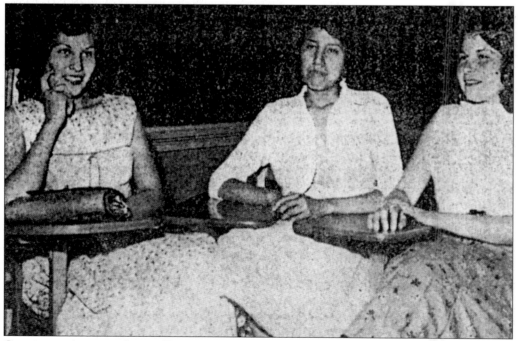

CHEYENNE AGENCY GIRLS, FLANDREAU, SOUTH DAKOTA. Attending a youth conference, from left to right, are Arlene Fast Horse, Mary Clown, and Patsy LeBeau. (Photograph courtesy of *Aberdeen American News*.)

Seven

OKOLAKICIYE AKICITA
(Soldier Society/Veterans)

This section is dedicated to all veterans who have served in the United States of America military divisions. Native Americans in the United States volunteer for military service at the highest rate of any group; 50 percent of all Native Americans are veterans. The greatest number, including those from Cheyenne River Indian Reservation, join the United States Marines or Special Forces within the military.

It was honorable to be a good warrior and today it is for the United States of America that the Lakota people serve. This book is filled throughout with warriors and veterans, both men and women. It is not well known that the Lakota also served as Codetalkers in World War II, along with other tribes.

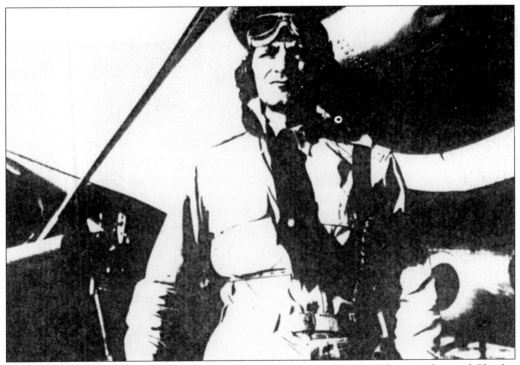

JOHN C. WALDRON, UNDATED. John was a Fort Pierre World War II hero and son of Charles Waldron and Jan Van Meter Waldron. He was a member of the Cheyenne River Sioux Tribe. An airfield in Corpus Christi, Texas, a navy destroyer, and a street in Chicago were all named after him. (Photograph courtesy of *South Dakota History*, Fall 1992.)

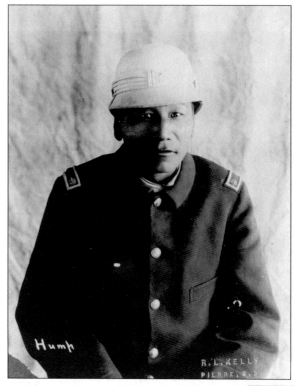

HUMP (MINNICOUJOU), PHOTO BY R.L. KELLY OF PIERRE, SOUTH DAKOTA, UNDATED. Hump is in uniform as an enlisted U.S. Scout. (Photograph courtesy of Donovin Sprague.)

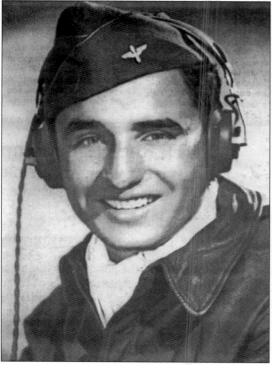

CAPTAIN HOMER CLAYMORE. Inducted into the South Dakota Aviation Hall of Fame, his plane was shot down during World War II ending his life. At the time he was serving in the U.S. Air Corp. His ancestor, Bazil Claymore, was a fur trader, (Photograph courtesy of the *Eagle Butte News*.)

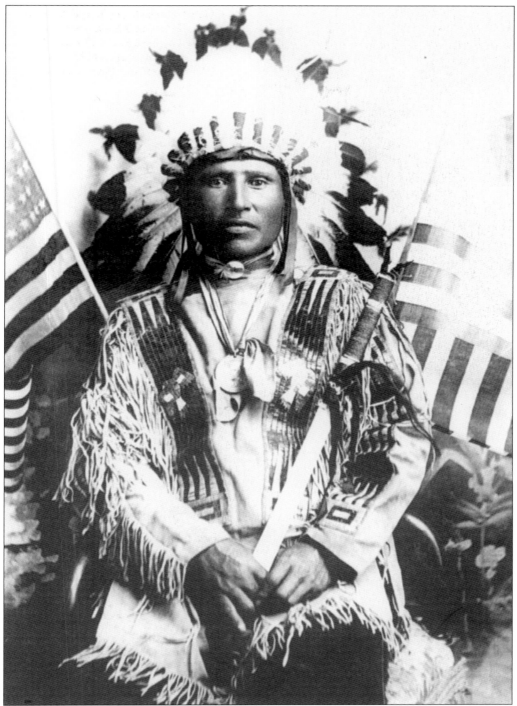

UNIDENTIFIED LAKOTA, PHOTO UNDATED. He wears a buckskin shirt decorated with porcupine quillwork, a Presidential Peace Medal, headdress of eagle feathers, and a pipe. The American flag is also pictured. (Photograph courtesy of South Dakota Historical Society.)

ALBERT MARSHALL JR., UNDATED.
(Photograph courtesy of Ruby Marshall and Edith Traversie.)

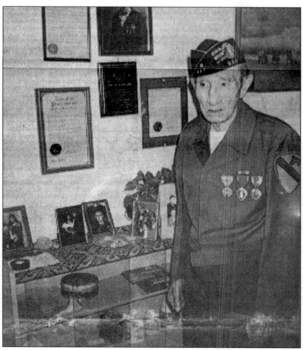

PHILIP LABLANC, TAKEN IN RAPID CITY, SOUTH DAKOTA. He served with the 1st Cavalry from 1942-46. He was also a Lakota Code Talker and here is displaying his medals. (Photograph by Kevin Peniska, *Indian Country Today.*)

Eight
WAKPA WASTE OWAKIPAMNI TANNI
(Good River/Old Cheyenne Agency)

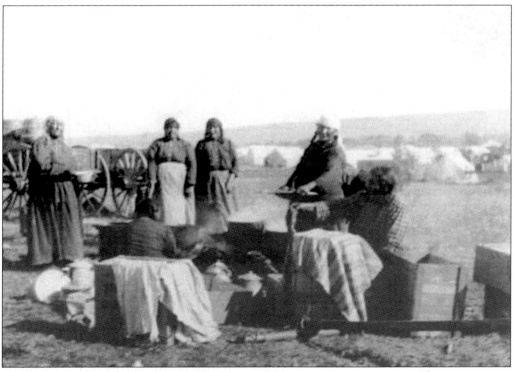

LAKOTA WINYAN (WOMEN) COOKING AT CHEYENNE RIVER, 1916. The women are unidentified, except the woman on the far lefts; she could be Molly Laundreaux. (Photograph courtesy of the Denver Public Library.)

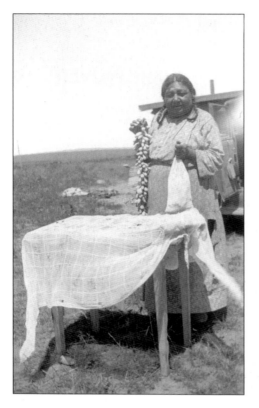

MINNICOUJOU WOMAN. This photo was taken at Cheyenne River Reservation sometime between 1915 and 1930. It is an unidentified U.S. Indian Service photo. The woman is preparing to make timpsila which is the Lakota name for braided prairie turnips. (Photograph courtesy of the Denver Public Library.)

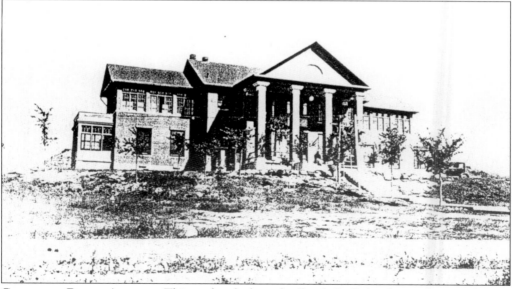

CHEYENNE RIVER AGENCY. This undated photo by Frank B. Fiske shows the government hospital. (Photograph courtesy of North Dakota State Historical Society.)

WHITE BULL'S DAUGHTER (MINNICOUJOU). This is an undated photo taken by S.J. Morrow. (Postcard courtesy of Donovin Sprague.)

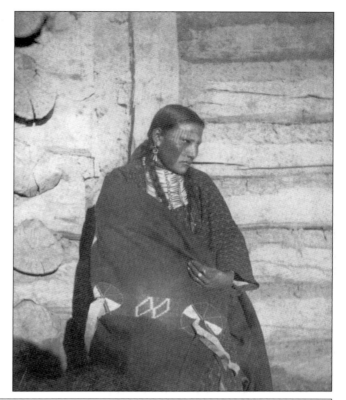

CHEYENNE AGENCY, 1955. Shown here are the school, gymnasium, and school playground. The tall brick chimney at left is the power plant area, which was dismantled before the Oahe Dam was built and flooded the Agency. (Photograph submitted by Terry Mayes, courtesy of Lawrence and Marion Mayes Estate.)

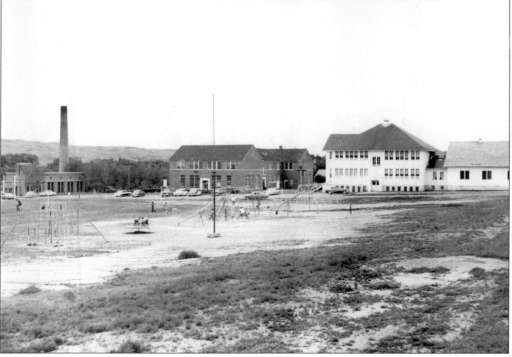

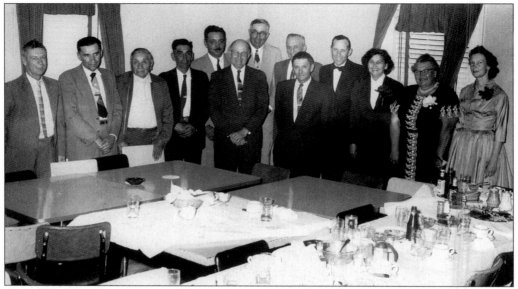

CHEYENNE AGENCY, 1955. Pictured here is a tribal reception for the start of the Rehabilitation Program. Chairman Frank Ducheneaux and his wife Babe are present along with the director of the program, Lawrence Mayes and his wife Marion. Pictured from left to right are Francis Cole, Andrew LeBeau, Felix Benoist Jr., Amos Claymore, Leonard Claymore, Superintendent Duchene, two unidentified, Frank Ducheneaux (chairman), Lawrence Mayes, Babe Ducheneaux, Phoebe Downing, and Marion Mayes. (Photograph submitted by Terry Mayes, courtesy of Lawrence and Marion Mayes Estate.)

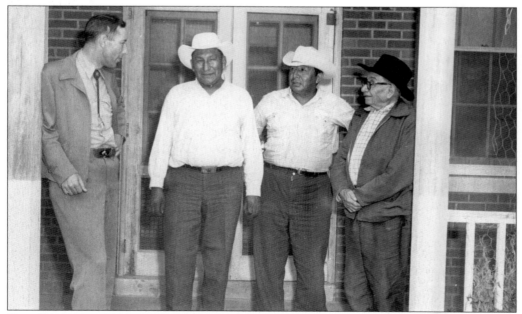

OLD CHEYENNE AGENCY, 1955. Pictured from left to right are Lawrence Mayes (Director), with committee members Alex Chasing Hawk, Isaac "Ike" Long, and Felix Benoist, Jr. (Photograph submitted by Terry Mayes, courtesy of Lawrence and Marion Mayes Estate.)

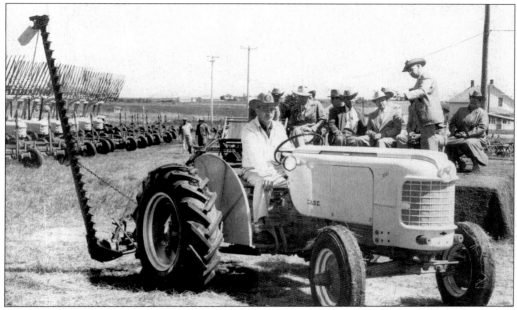

GRAND OPENING OF REHABILITATION PROGRAM, 1955. Ray B. Hyde, operational manager, is shown with tribal and U.S. government officials in background. Case tractors were purchased from a Gettysburg, South Dakota dealership along with GMC trucks. (Photograph submitted by Terry Mayes, courtesy of Lawrence and Marion Mayes Estate.)

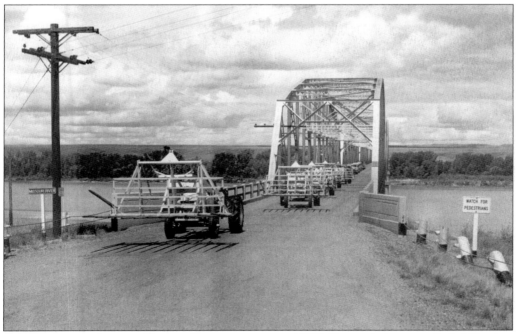

OLD CHEYENNE AGENCY BRIDGE PHOTO TAKEN IN 1955. Pictured above are Rehabilitation Program tractors arriving at Whitlock Crossing on Highway 212, across the Missouri River. (Photograph submitted by Terry Mayes, courtesy of Lawrence and Marion Mayes Estate.)

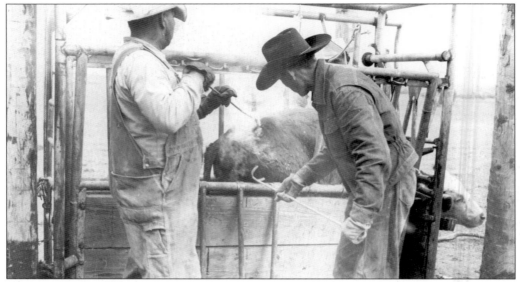

OLD CHEYENNE AGENCY PHOTO c. 1955. Isaac "Ike" Long (on the left) and another man not clearly identified, brand cattle as part of the Rehab Program. (Photograph submitted by Terry Mayes, courtesy of Lawrence and Marion Mayes Estate.)

OLD CHEYENNE AGENCY PHOTO TAKEN IN 1955. Under the Rehabilitation Program cattle were purchased for tribal members to encourage them to build herds and become ranchers/farmers. The area is now covered by the Missouri River. (Photograph submitted by Terry Mayes, courtesy of Lawrence and Marion Mayes Estate.)

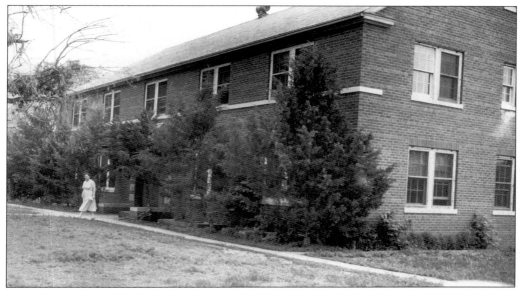

OLD CHEYENNE AGENCY RESIDENCE HOUSE, PHOTO TAKEN IN 1955, WHITLOCK CROSSING.
The woman is Josephine (Halfred) Berry. (Photograph submitted by Terry Mayes, courtesy of Lawrence and Marion Mayes Estate.)

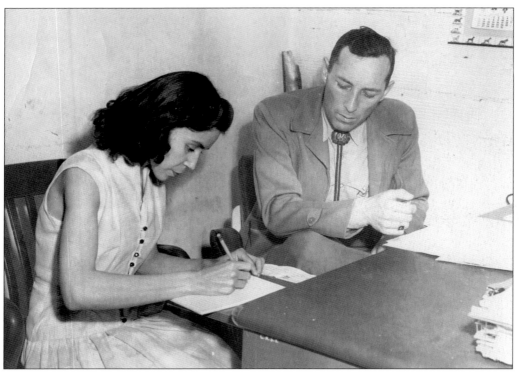

CHEYENNE AGENCY OFFICE WORKERS, PHOTO TAKEN IN 1955. On the right is Lawrence Mayes and the woman is believed to be the daughter of Sidney LeBeau. (Photograph submitted by Terry Mayes, courtesy of Lawrence and Marion Mayes Estate.)

ETTA CRAWFORD LAPLANT, PHOTO TAKEN IN 1955, CHEYENNE AGENCY TRIBAL OFFICE.
(Photograph submitted by Terry Mayes, courtesy of Lawrence and Marion Mayes Estate.)

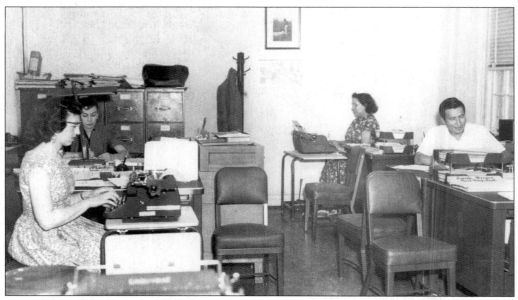

OLD CHEYENNE AGENCY, WHITLOCK CROSSING. This 1955 photo shows tribal employees at work. Name plates on the desks read: Joseph Brewer (right) and "Ms. La Plante" (on left, in background). The man at the right is not Joseph Brewer, his desk is vacant. From left to right are Gladys LeBeau (front, left), Etta Crawford La Plante (in back, left), Marie LeBeau (back, right). The man on the right is believed to be Casimir LeBeau. (Photograph submitted by Terry Mayes, courtesy of Lawrence and Marion Mayes Estate.)

Nine

WICOICAGE TOKAHE (The Next Generation)
WACIPI (Powwows)
SUNKWATOGLA AKANYANKA (Rodeo)
PSA WOGNAKE TAP SKATA (Basketball)
SKAL O MANI PI (Sporting Events)

There are many outstanding dancers in Powwow competition and many very pretty wicincalas who have won contests for their dress, appearance, competition, and personality. Codi High Elk won the Miss Indian World contest, Jeri LeBeau won Miss Indian America, and Marina Allison won several titles.

In all the areas listed above in the chapter title, the people of the Cheyenne River Indian Reservation have excelled. To list and have a photo of everyone in these areas would fill a large book itself.

GRACE CARLIN ROUSSEAU (MINNICOUJOU), UNDATED. Grace is the daughter of Doug and Marcella Carlin. She is wearing her mother's wedding dress in this parade. (Photograph courtesy of Neil Rousseau and Dee Schumacher.)

JERILYN LeBEAU, PHOTO TAKEN IN 1981. Jeri was Miss Indian America XXVII. Her mother is Maida White Feather LeBeau. (Photograph courtesy of Donovin Sprague.)

BUD LONGBRAKE, TAKEN AT CRAZY HORSE MEMORIAL STAMPEDE RODEO. Bud is a world champion saddle bronc rider and is pictured here with the winning ride at the event. He is the son of Pete and Faye Longbrake. Horses and rodeo are an important part of the lives of many tribal members. The area has produced many top competitors in professional rodeo. (Photograph courtesy of Newspaper.)